COLOR-BY-NUMBER
ANIMALS

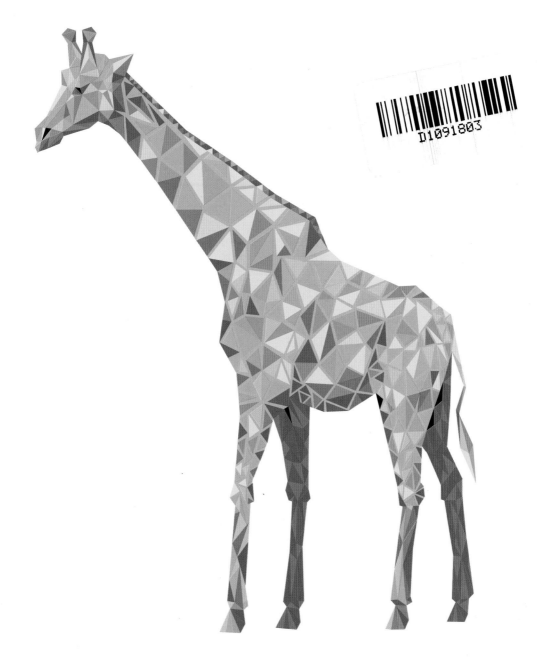

30+ FUN & RELAXING COLOR-BY-NUMBER PROJECTS TO ENGAGE & ENTERTAIN

Quarto is the authority on a wide range of topics.
Quarto educates, entertains, and enriches the lives of our readers—
enthusiasts and lovers of hands-on living.
www.quartoknows.com

© 2016 Quarto Publishing Group, USA Inc.
Published by Walter Foster Publishing,
A division of Quarto Publishing Group USA Inc.
All rights reserved. Walter Foster is a registered trademark.

Written and designed by Elizabeth T. Gilbert. Images on
pages 6 and 10, 11 (except pencil photo), 12 (photos only),
13, 14 (except rhinos A and B), 15 © Elizabeth T. Gilbert.
All other images © 2016 Shutterstock.
All rights reserved.

6 Orchard Road, Suite 100
Lake Forest, CA 92630
quartoknows.com
Visit our blogs at @quartoknows.com

Printed in China
3 5 7 9 10 8 6 4

COLOR-BY-NUMBER
ANIMALS

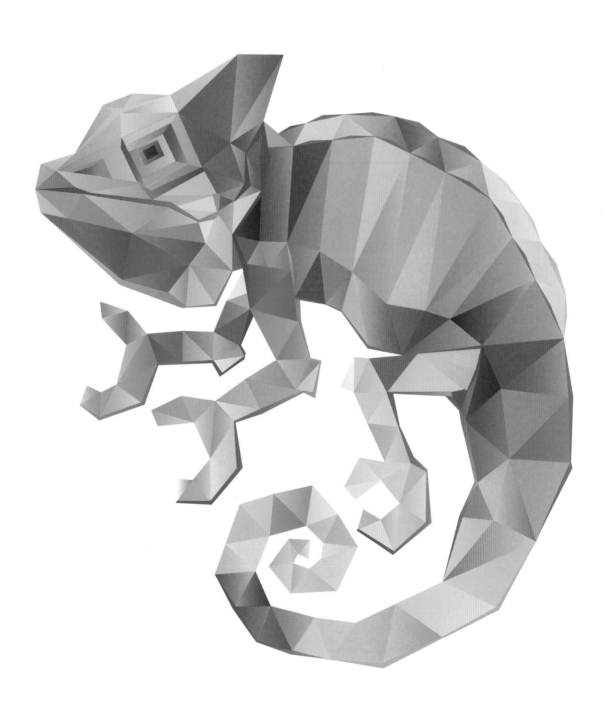

CONTENTS

Advanced	Gallery	Template

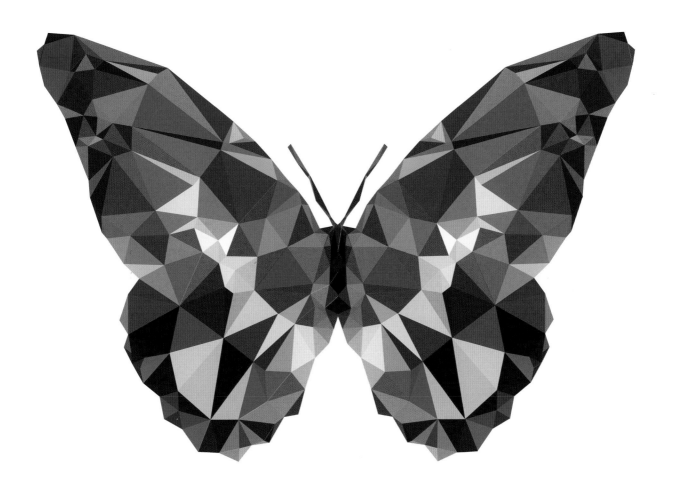

INTRODUCTION

A growing body of research suggests that coloring is more than just a favorite childhood activity—it benefits adults too! Coloring activates parts of the brain involved in fine motor skills and vision, in turn diminishing activity in areas associated with stress. More and more adults find that coloring is a soothing, meditative activity that contributes to a healthy lifestyle. Grab your coloring tools and join the movement!

In this book, we make it easy for you to reap the benefits of coloring while creating vibrant, modern works of art. The templates inside feature black outlines for 32 different works of polygonal art—a contemporary geometric style that lends itself perfectly to the art of coloring. You can tear out and color directly on the sheets in this book, or you can copy the templates onto your own paper for endless coloring fun.

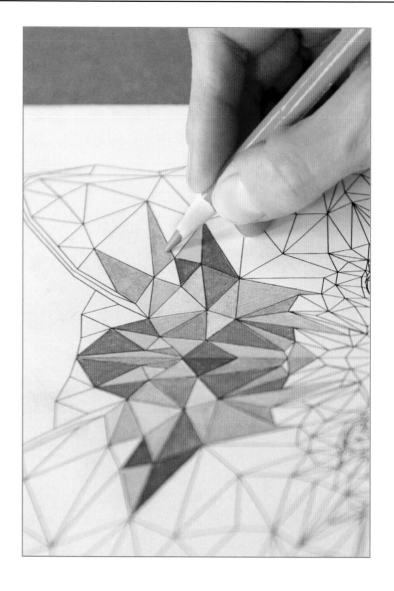

The templates are organized in three levels: beginning, intermediate, and advanced. The beginning templates feature a light gray number in most polygons; the number corresponds to a basic Color Number Key (page 16), telling you which colors to use in order to match the finished examples shown in the gallery. The key allows you to forego any decision-making as you work toward striking results. The intermediate templates include some color numbers, and the advanced templates do not include any color numbers. You may choose to follow the numbers and refer to the colored examples in this book, or you may use your own selection of colors to develop a unique piece of art. The choice is yours!

BEGINNING

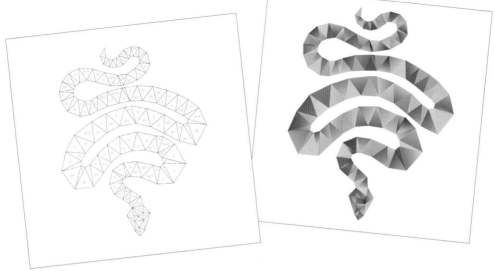

INTERMEDIATE

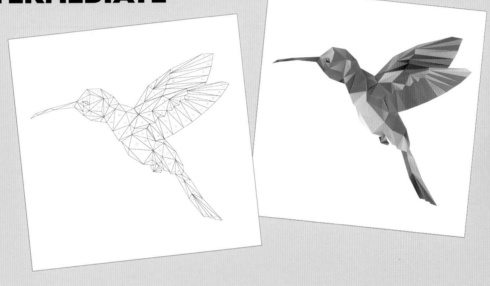

ADVANCED

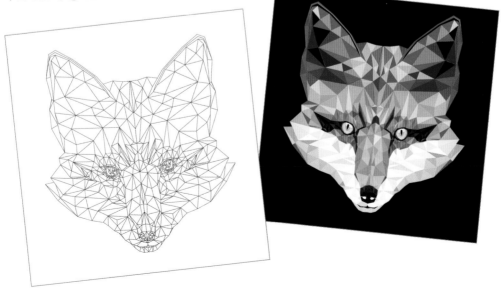

TOOLS & MATERIALS

Before you begin coloring the templates in this book, get to know the range of tools available. Each medium has a unique feel and appearance, so choose the tools that best suits your style or mood.

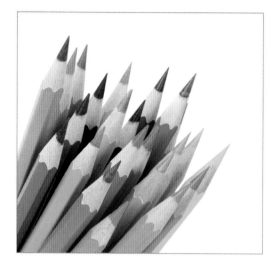

COLORED PENCILS

Colored pencils are wood-encased leads made up of pigment and wax. Like traditional graphite pencils, you can sharpen them to points that can create fine lines and (if used at an angle) broad strokes. They give you a good amount of control over your strokes; the harder you press, the darker the line. You can also use an eraser to tidy up your lines.

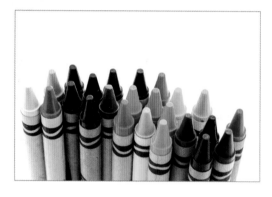

CRAYONS

Crayons are a playful, inexpensive way to color your drawings. These wax-based tools have a soft feel and provide quick, textured coverage. Because they wear down quickly, crayons do not have sharp points for coloring in small areas.

MARKERS

Through tips made up of fibers, markers deliver ink from a reservoir onto paper. The marks are bold, crisp, and rich in color. Markers generally come in three types of tips: chiseled (wide and firm), fine (small and firm), and brush (soft and tapered).

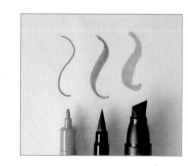

ADDITIONAL MATERIALS

Other tools you may want to have on hand include:

- A drawing board to support your paper as you color
- A vinyl or plastic eraser (for colored pencils)
- An electric or hand-held sharpener (for colored pencils)
- A soft brush for removing dust and eraser crumbs (for colored pencils)

Colored pencils and markers are available individually and in sets at your local art-supply store. Always purchase the best quality you can afford, as high-quality tools yield better results. Student-grade materials (in contrast to artist-grade materials) contain a higher filler-to-pigment ratio, which affects the feel of the tools and vibrancy of the colors.

EXPLORING OTHER MEDIA

Colored pencils, crayons, and markers may be the most convenient coloring media, but you're certainly not limited to them—especially if you're after soft blends or expressive, painterly effects. If desired, you can try soft pastel, oil pastel, watercolor paint, gouache paint, or acrylic paint. Note that if you plan to work with paint, you'll want to transfer the template to an appropriate support (such as watercolor paper or canvas). See page 15 for more on transferring.

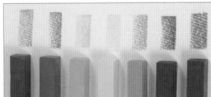

Soft Pastel These chalk-like tools yield textured strokes and smooth blends. They are available in both stick and pencil form. These work best on textured drawing paper.

Oil Pastel Similar to crayons, these oil-based sticks produce thick, lively strokes. These work best on textured drawing or watercolor paper.

Watercolor This water-based paint is great for creating soft, translucent washes of color. To use this fluid medium, transfer your template to a sheet of watercolor paper.

Watercolor Pencil Similar to colored pencils, you can use these to fill in the polygons of your templates. Then stroke a wet brush over to transform your strokes into wet washes of color. This medium also works best on watercolor paper.

Acrylic You can apply this water-based paint thinly (similar to watercolor) or thickly (similar to oil). Acrylic works best on canvas or watercolor paper.

Brushes When working in watercolor, you can use either natural or synthetic soft-haired brushes. When working in acrylic, synthetic bristles are best. Always rinse your brushes with warm, soapy water after use, and reshape the bristles to dry.

TECHNIQUES

Learn to manipulate colored pencil, crayon, and marker to create a range of textures and effects. The following pages show you some of the most common techniques, but experimentation shouldn't stop here—try coming up with your own unique methods for coloring with these tools! Each technique is shown using colored pencil (left), crayon (center), and marker (right).

Colored Pencil

Crayon

Marker

Flat Color Apply pressure evenly as you stroke back and forth to fill an area with solid color.

Hatching Apply parallel lines to shade an area. The closer the lines, the darker the shading will appear.

Blending To blend colors, lighten the pressure of your pencil and overlap strokes where the colors meet.

Scumbling Apply colored pencil or crayon using small, circular strokes, which creates a soft, even texture.

Gradating Stroke side to side with heavy pressure, and lighten as you move away, exposing more of the white paper beneath.

Colored Pencil	**Crayon**	**Marker**

Crosshatching Apply parallel lines to shade an area; then apply another series of parallel lines at a different angle.

Stippling Apply small dots of color to shade or create texture. The closer the dots, the darker the stippling will "read."

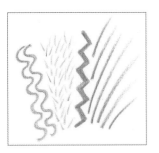	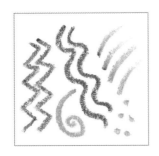	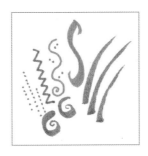

Stroking Experiment with the tip of the colored pencil to produce a range of lines—from squiggles and zigzags to tapered strokes.

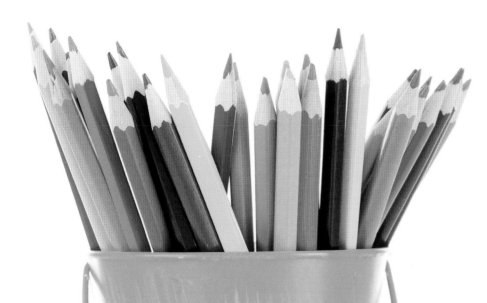

Burnishing Press hard as you apply a layer of white colored pencil over flat strokes of color. This will blend the strokes for a smooth, shiny finish (center, above).

Mixing To mix markers, apply one color over another. They will blend in a way similar to paint; for example, blue over yellow creates green.

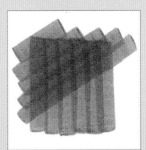

Layering The more you layer your strokes, the darker the color will appear. However, too many layers can wet the paper and cause it to tear.

USING THE TEMPLATES

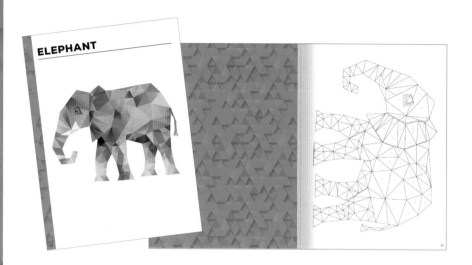

STEP 1

Select an image to color (pages 17 to 48) and find the corresponding template (pages 49 to 111). Remove the template from the book.

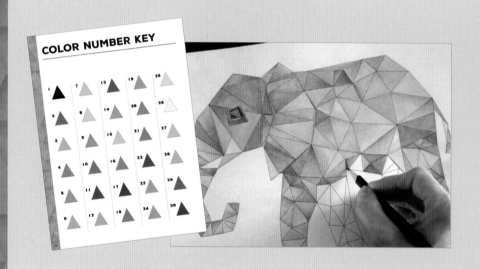

STEP 2

Gather your coloring tools and materials. The beginning and intermediate templates include color numbers in most spaces, which correspond to the key on page 16. Use the suggested colors to fill in each shape of the template.

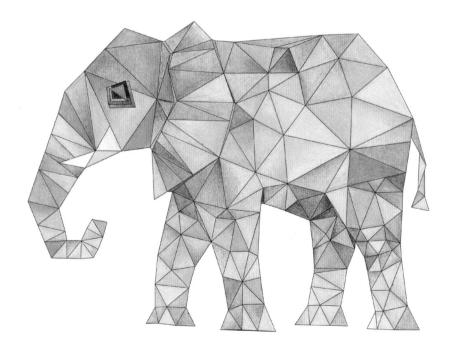

STEP 3

Enjoy your completed color-by-number masterpiece!

TIP

If desired, you can multiply the templates in this book! Before coloring them, consider creating grayscale photocopies of each. You can also transfer the templates to fresh sheets of drawing paper (see page 15).

COLORING STYLES

In addition to applying flat colors according to the color number key, you can take a few different approaches to coloring. Below are some suggestions; remember to follow what feels most natural to you!

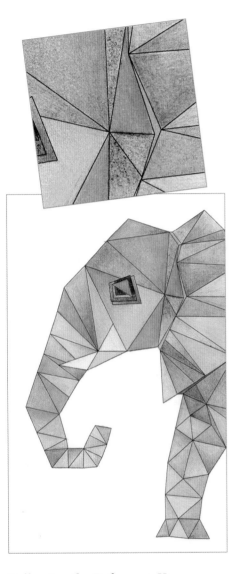

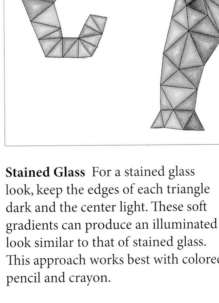

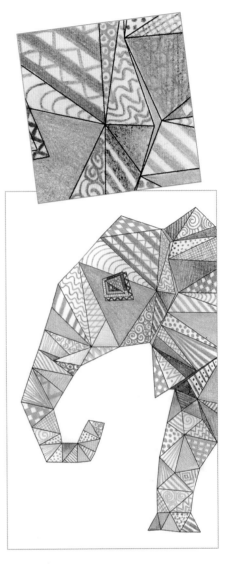

Following the Reference You may choose to follow the colored reference exactly as it appears in the book. You'll notice that most of the triangles are not made up of single, flat colors—each triangle contains a bit of a gradation. Some gradations move simply from light to dark, while others move from one color into the next. Each triangle contains a recommended color number that corresponds to the key on page 16. Use this recommended number as the base, and then adjust your pencil's pressure or layer colors to match the reference.

Stained Glass For a stained glass look, keep the edges of each triangle dark and the center light. These soft gradients can produce an illuminated look similar to that of stained glass. This approach works best with colored pencil and crayon.

Doodling Use the number key to fill the triangles with a variety of strokes, from squiggles and dots to checkered and crosshatched designs. This intricate, energetic style produces unique results. This approach works best with colored pencil and marker.

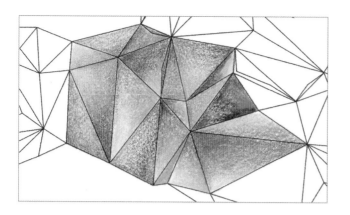

Creating Multi-Colored Polygons
Instead of following the color key, create multi-colored shapes. For each corner of the polygon, choose a different color and blend into neighboring colors as you move toward the center.

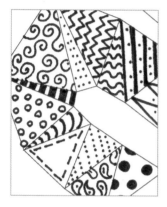

Adding to the Design Before adding color, enhance your polygonal template with intricate designs using a fine-tipped black marker. Then color over the designs with colored pencil or crayon.

A

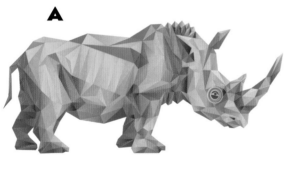

Selecting a Different Palette If you'd like to work with a different color palette than shown in the gallery (A), start by viewing the colored example in terms of value (the lightness or darkness of a color). You can do this by scanning or photographing the colored example and then converting the image to grayscale (B). Or, you can simply use a copy machine set to grayscale. This will allow you to see the value of each polygon. In this example, notice how the values help us "read" the forms of the body. From here, you can build your work with your own choices of color while adhering to the suggested values (C).

B

C

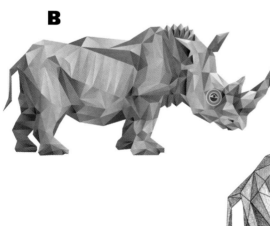

HOW TO TRANSFER A TEMPLATE

Use your template multiple times by transferring the lines onto a separate sheet of paper. You can even transfer the lines onto watercolor paper or canvas to work with pastel or paint. Simply follow the instructions below!

Step 1 Trace the template onto a sheet of tracing paper, or make a photocopy of the template onto a sheet of copy paper, scaling it to your desired size.

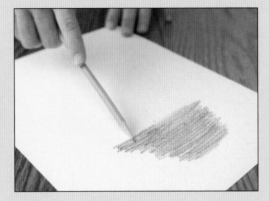

Step 2 Coat the back of the paper with a layer of graphite using a pencil. (In place of this step, you could purchase a sheet of graphite transfer paper.)

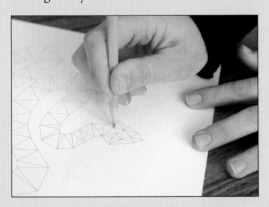

Step 3 Now place the template graphite-side down over your art paper or canvas. Using a pencil, ballpoint pen, or stylus, trace the template lines.

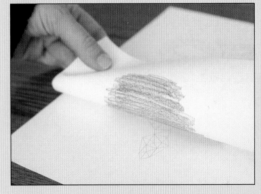

Step 4 Occasionally peel back the template to make sure the lines are transferring well to your drawing surface. The result will be a light guideline for creating your sketch!

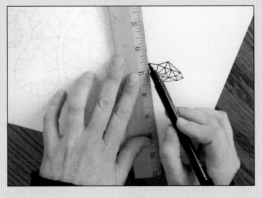

Step 5 If desired, use a ruler and a fine-tipped permanent marker to trace the transferred lines.

Step 6 The result is a fresh template ready for color!

COLOR NUMBER KEY

Before you begin the projects, choose your selection of coloring tools based on the color triangles on this page. These color numbers correspond to the numbers found on the beginning and intermediate templates (pages 49 to 87) to help you match the colored examples (pages 17 to 36). Remember: These colors serve as a general guide for your coloring experience, so your tools do not have to match exactly—and you might opt to ignore the numbers in favor of your own color palette.

1 Black

2 Dark gray

3 Gray

4 Red

5 Red-orange

6 Orange

7 Light orange

8 Pink

9 Magenta

10 Dark pink

11 Maroon

12 Light purple

13 Purple

14 Periwinkle

15 Light blue

16 Blue

17 Dark blue

18 Slate blue

19 Cyan

20 Blue-green

21 Green

22 Dark green

23 Yellow-green

24 Olive

25 Yellow

26 Pale yellow

27 Yellow ochre

28 Light brown

29 Brown

30 Dark brown

DOLPHINS

SEE **PAGE 49** FOR PROJECT

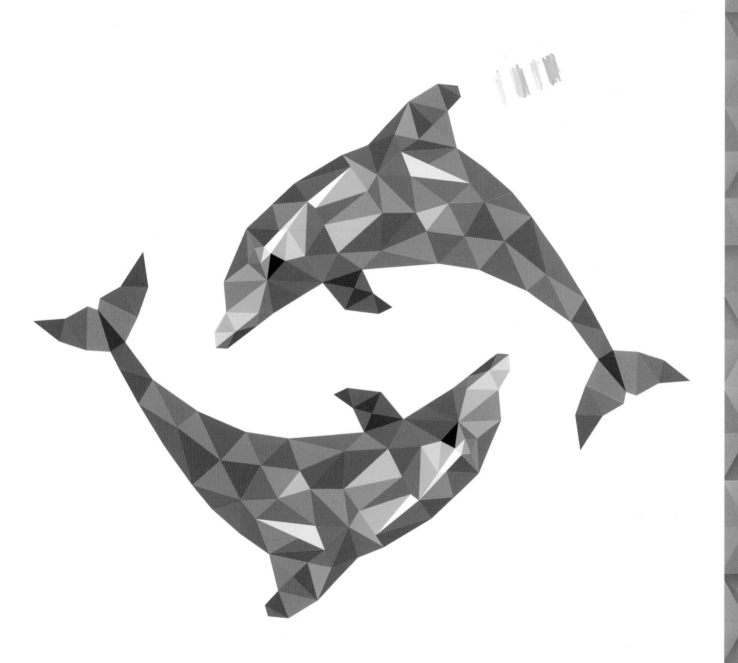

ELEPHANT 1

SEE **PAGE 51** FOR PROJECT

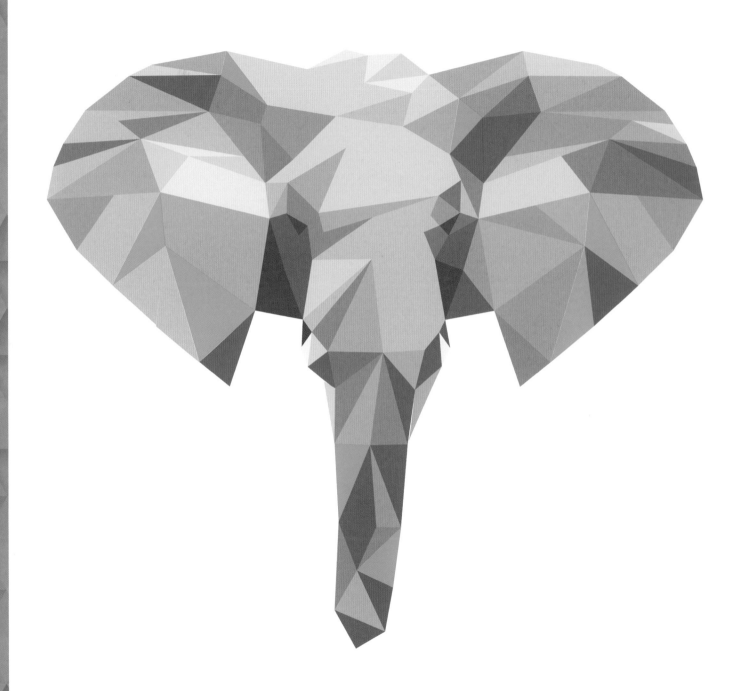

ADDITIONAL COLOR NUMBERS:

31	32	33	34	35
Light gray 1	Light gray 2	Middle gray	Dark gray 1	Dark gray 2

FLAMINGO

SEE **PAGE 53** FOR PROJECT

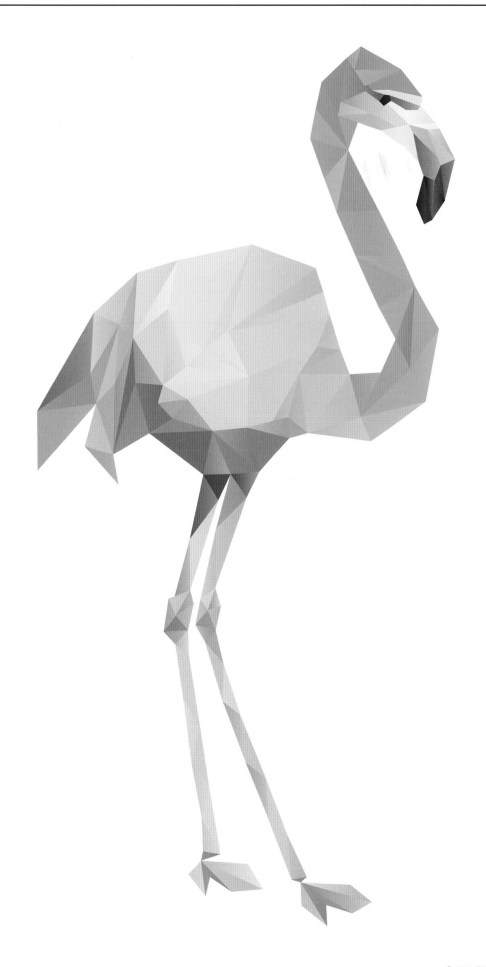

HIPPO

SEE **PAGE 55** FOR PROJECT

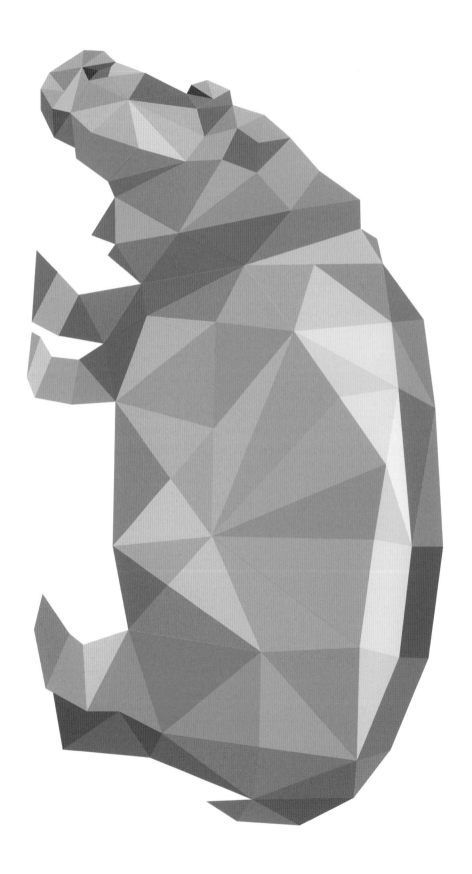

HORSE

SEE **PAGE 57** FOR PROJECT

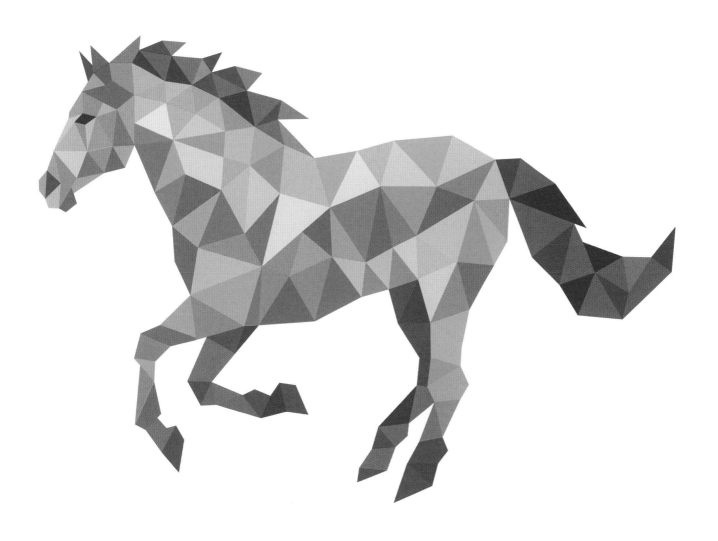

JELLYFISH

SEE **PAGE 59** FOR PROJECT

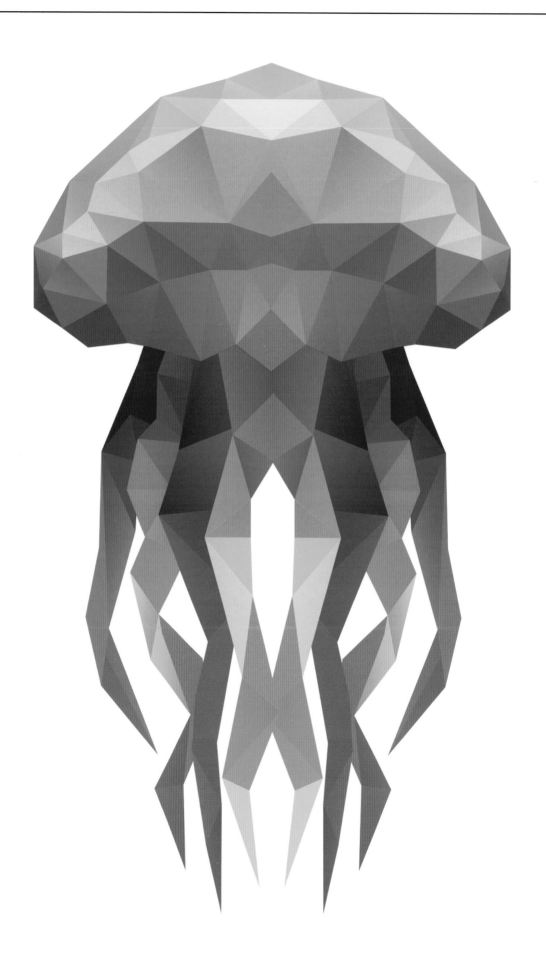

ROOSTER

SEE **PAGE 61** FOR PROJECT

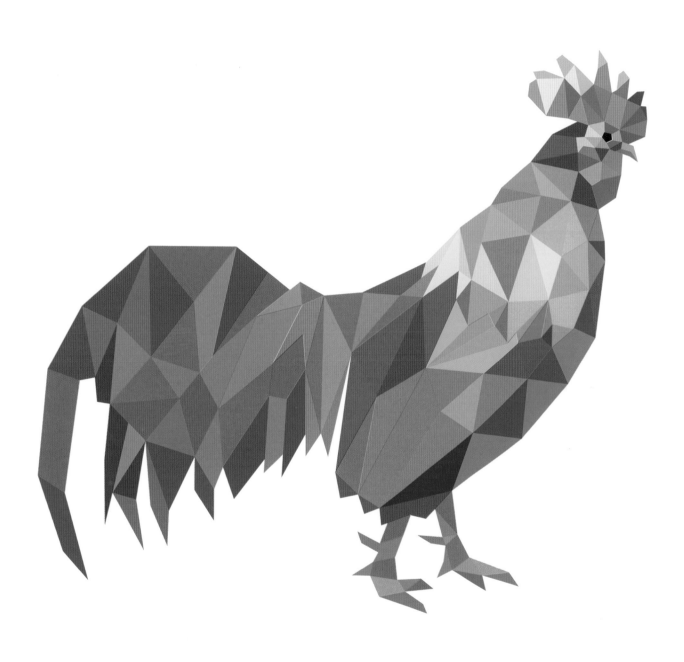

SNAKE

SEE **PAGE 63** FOR PROJECT

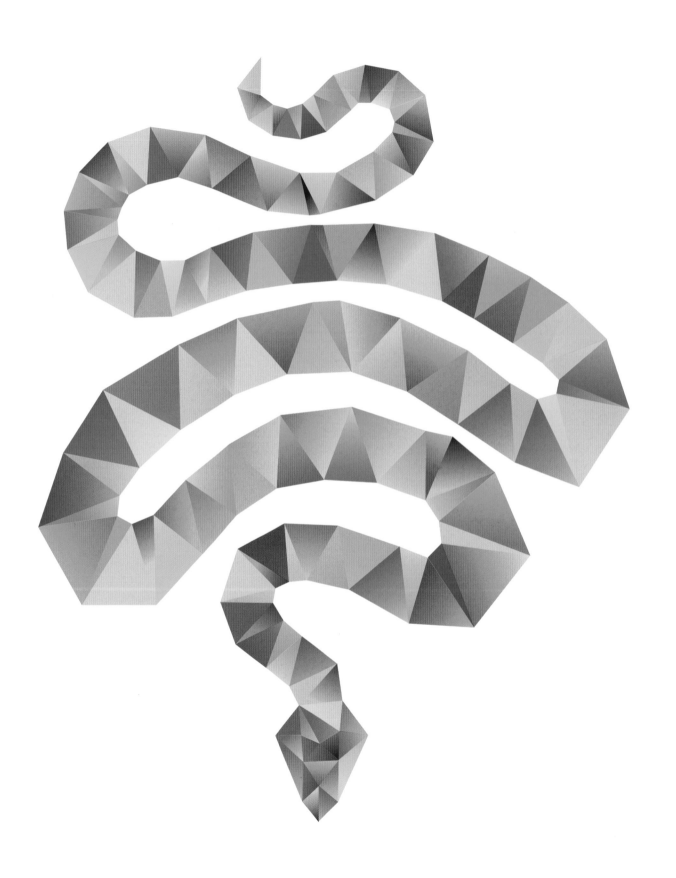

CAMEL

SEE **PAGE 65** FOR PROJECT

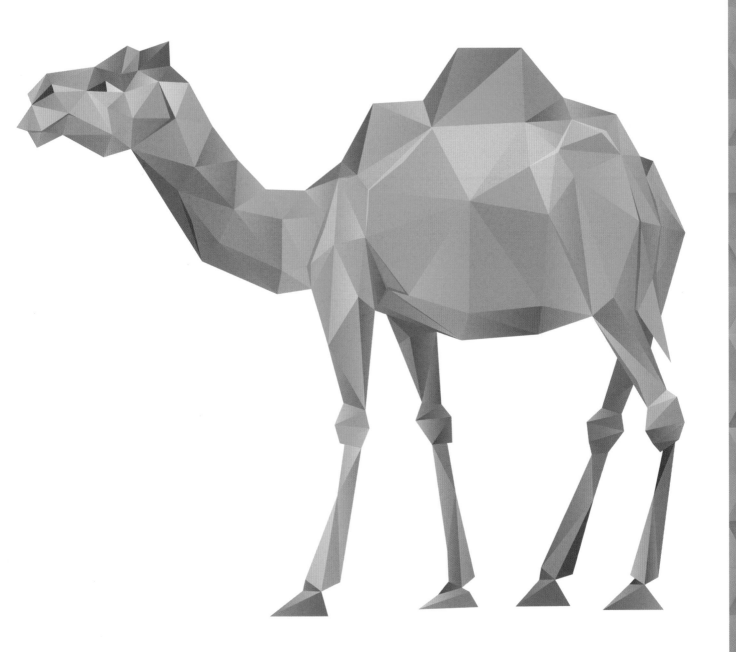

BEARS

SEE **PAGE 67** FOR PROJECT

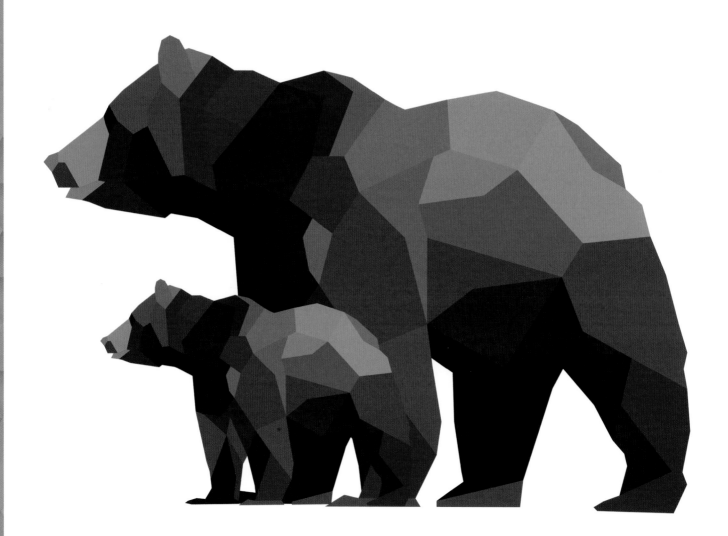

LION

SEE **PAGE 69** FOR PROJECT

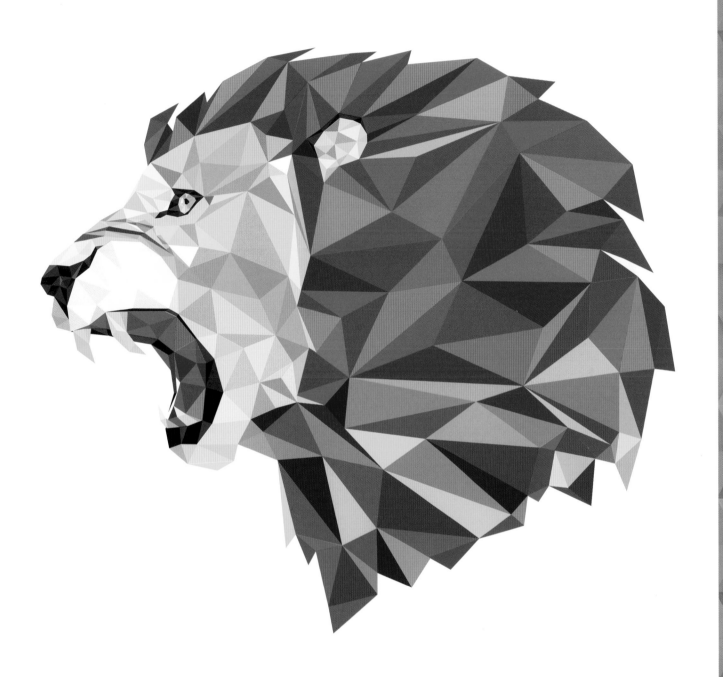

HUMMINGBIRD

SEE **PAGE 71** FOR PROJECT

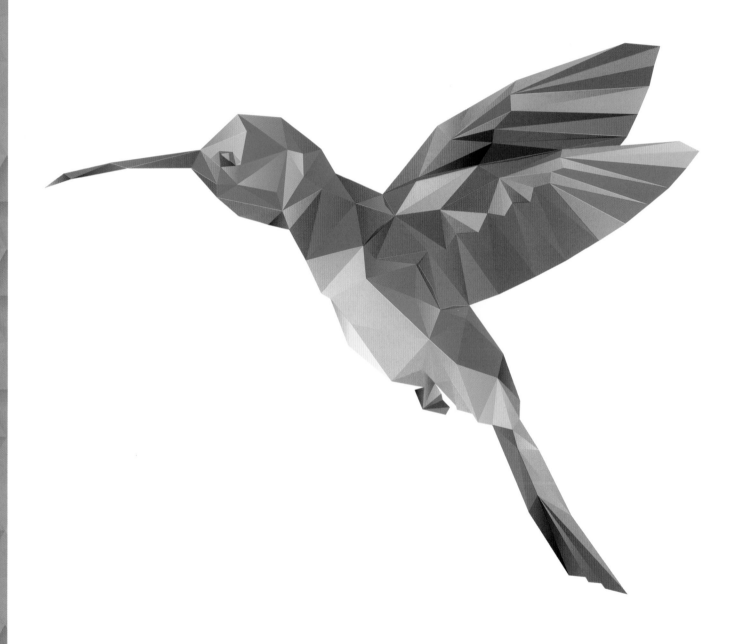

LOVEBIRDS

SEE **PAGE 73** FOR PROJECT

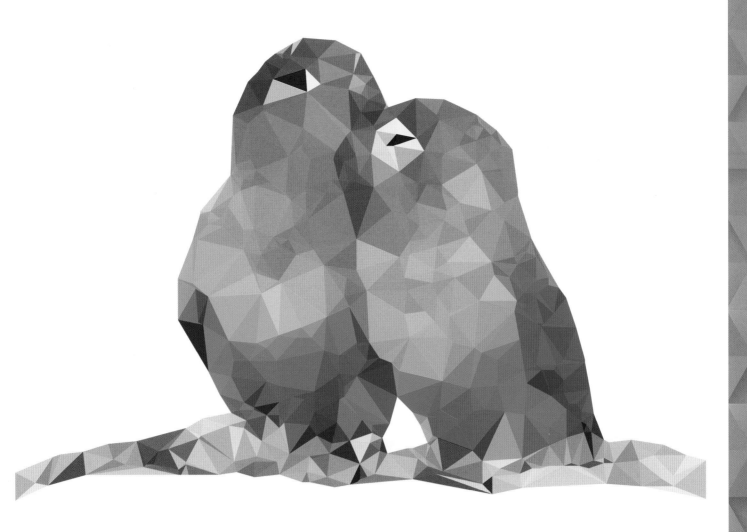

ELEPHANT 2

SEE **PAGE 75** FOR PROJECT

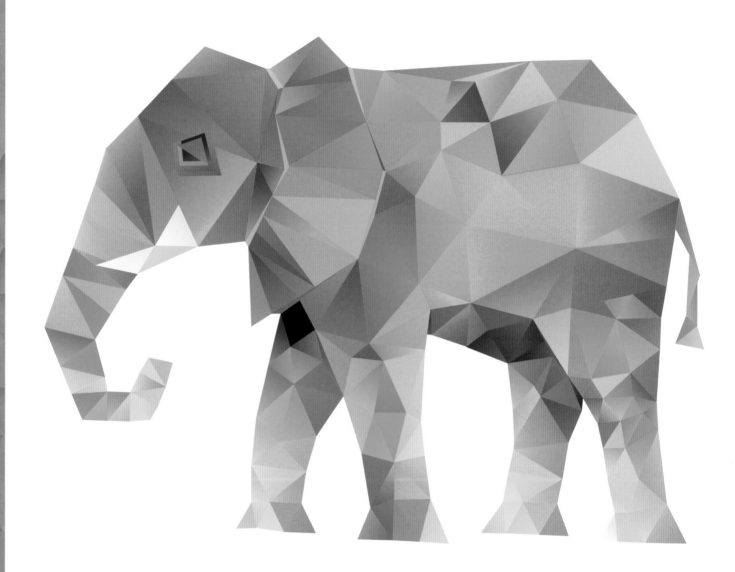

GALLERY • Intermediate

RHINOCEROS

SEE **PAGE 77** FOR PROJECT

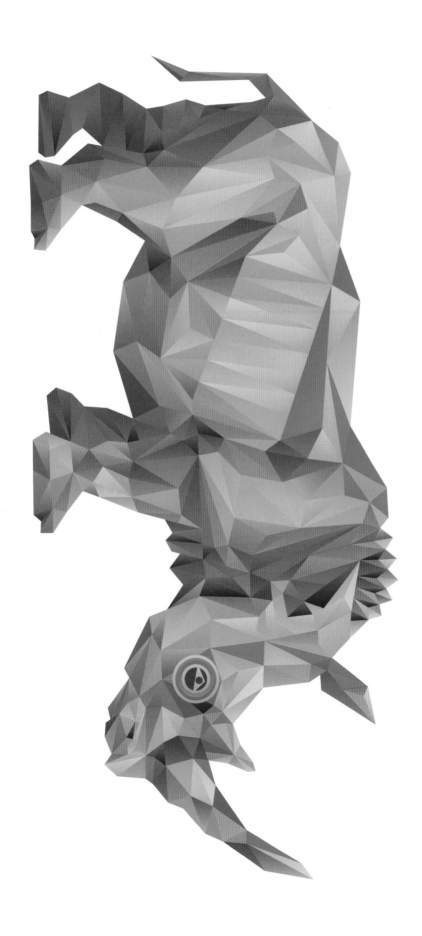

BLUE BUTTERFLY

SEE **PAGE 79** FOR PROJECT

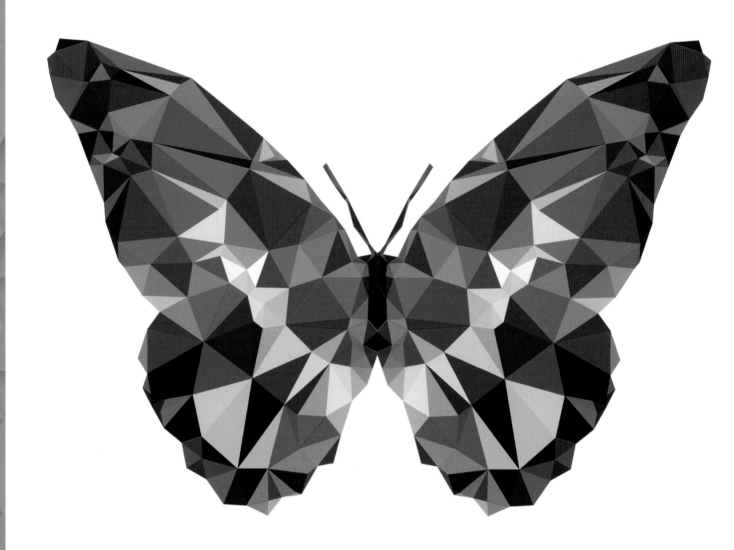

GALLERY • Intermediate

RED BUTTERFLY

SEE **PAGE 81** FOR PROJECT

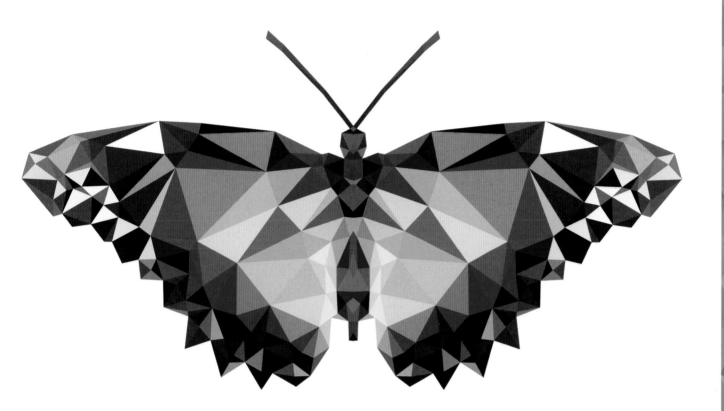

GIRAFFE

SEE **PAGE 83** FOR PROJECT

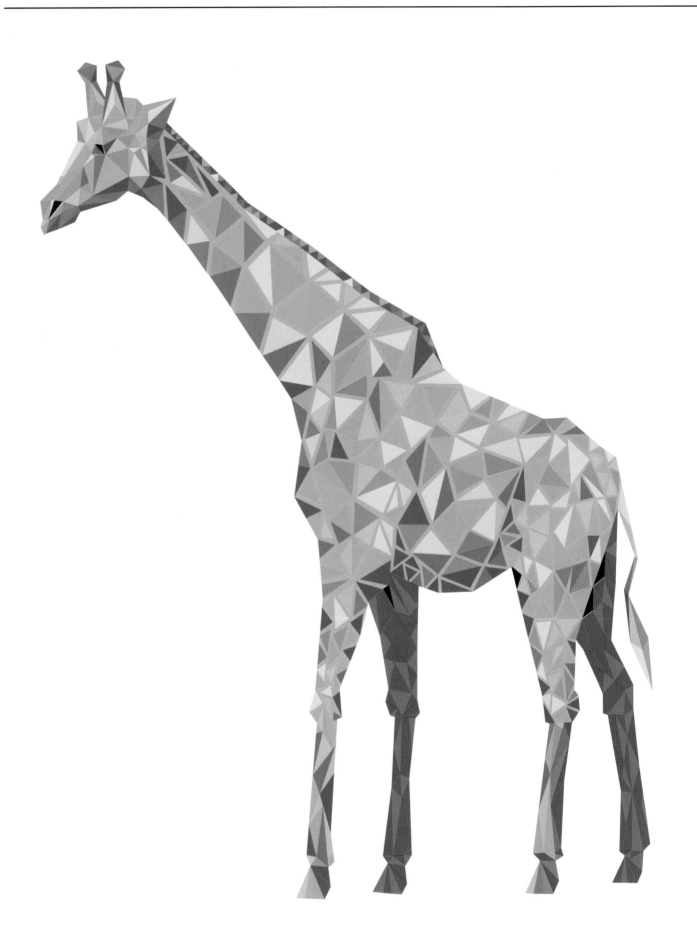

GALLERY ● Intermediate

CHAMELEON

SEE **PAGE 85** FOR PROJECT

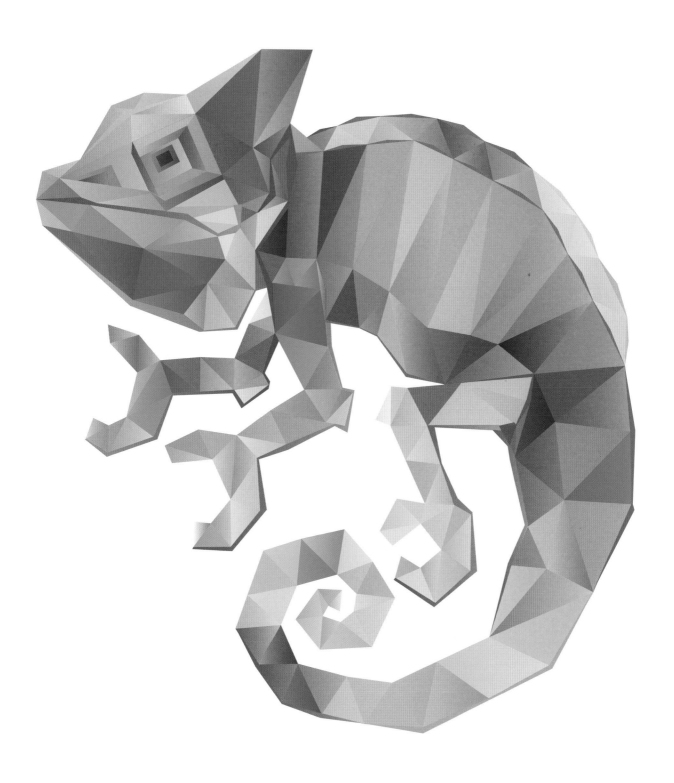

TIGER

SEE **PAGE 87** FOR PROJECT

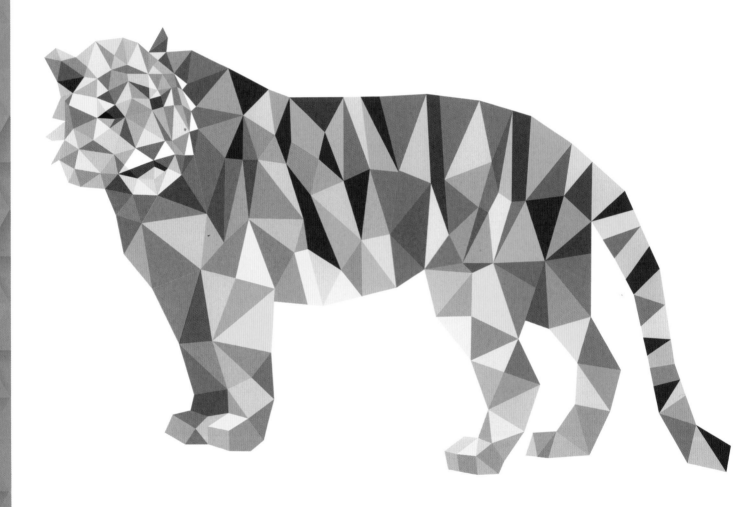

GALLERY • Intermediate

BULL

SEE **PAGE 89** FOR PROJECT

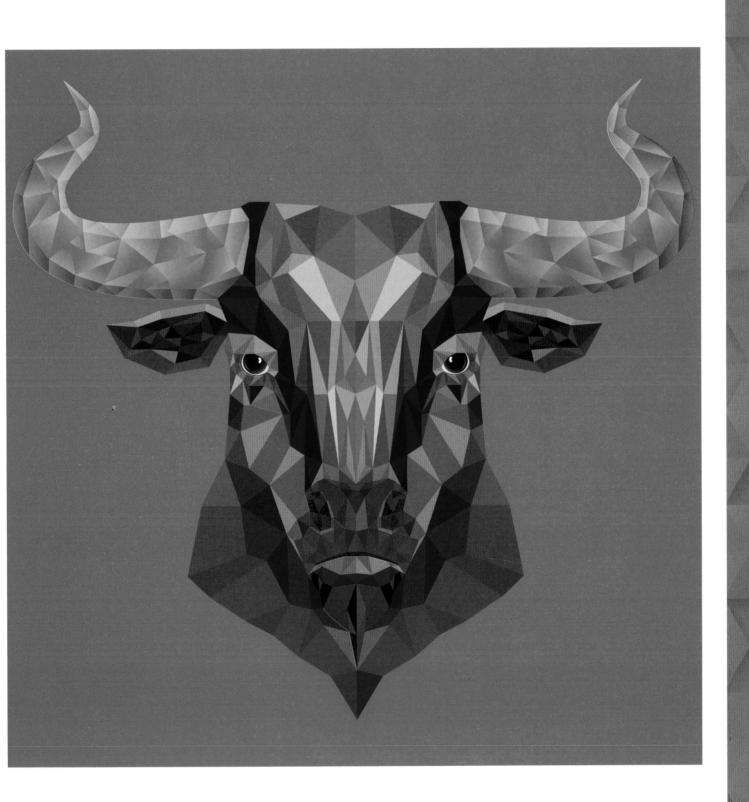

CAT

SEE **PAGE 91** FOR PROJECT

GALLERY • Advanced

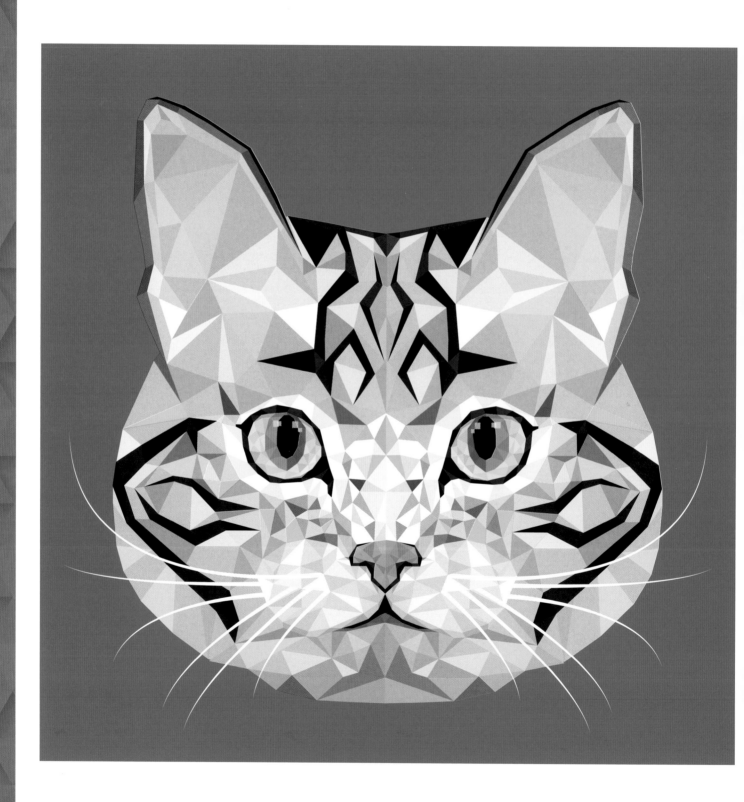

DOG

SEE **PAGE 93** FOR PROJECT

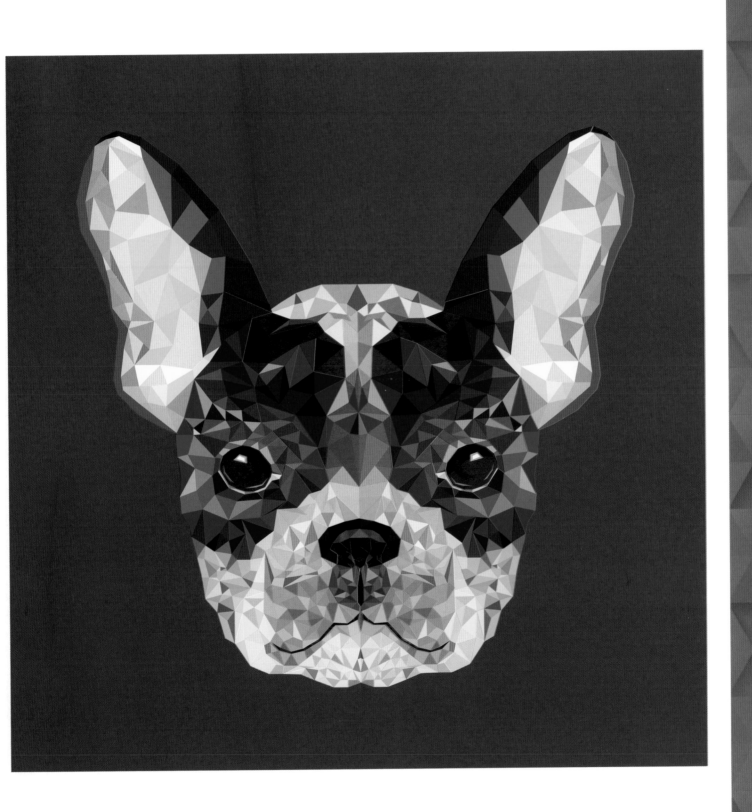

ELEPHANT 3

SEE **PAGE 95** FOR PROJECT

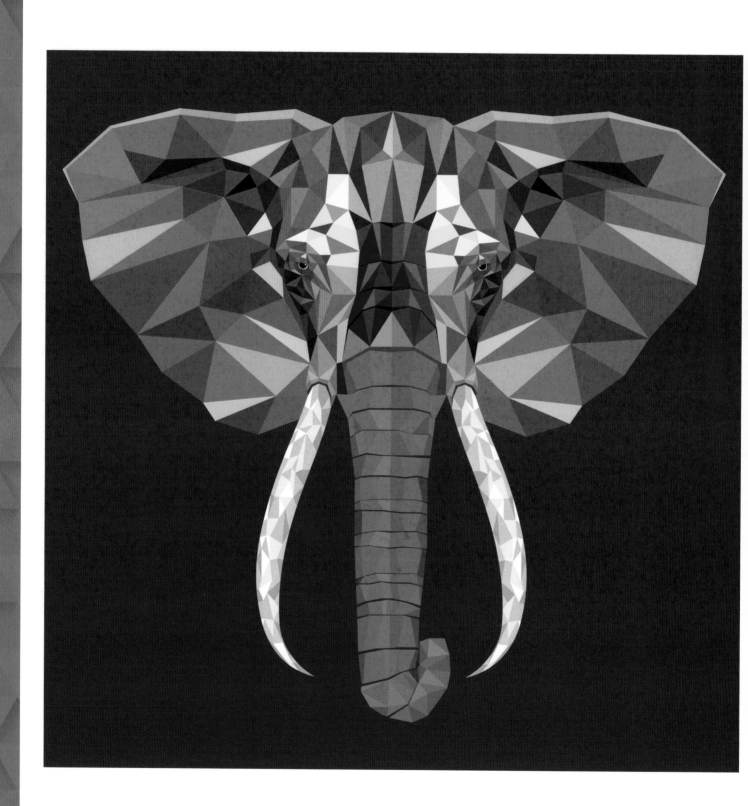

FOX

SEE **PAGE 97** FOR PROJECT

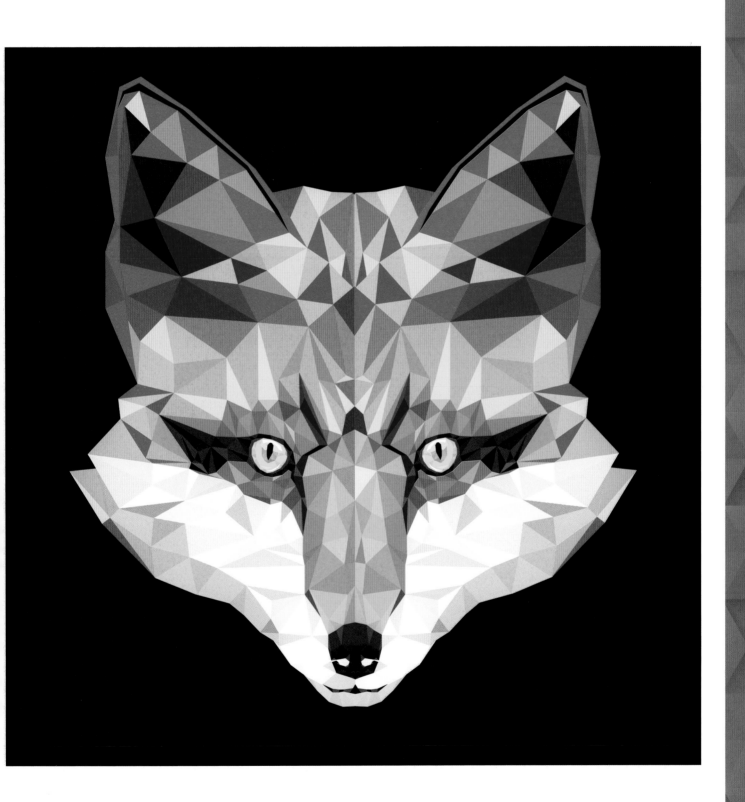

OWL

SEE **PAGE 99** FOR PROJECT

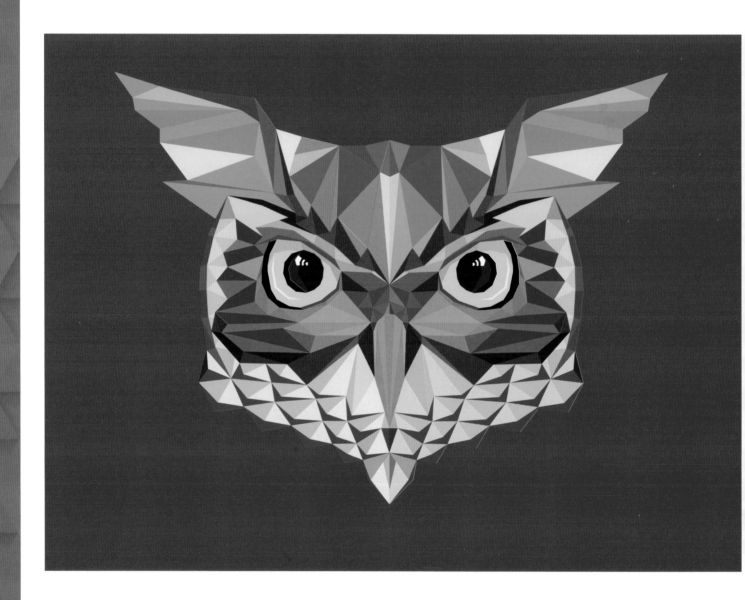

GALLERY • Advanced

RAM

SEE **PAGE 101** FOR PROJECT

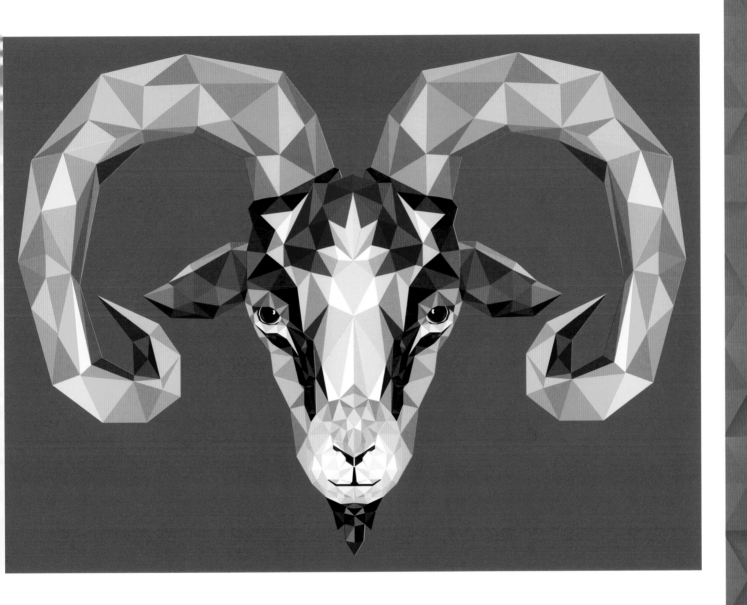

TIGER HEAD

SEE **PAGE 103** FOR PROJECT

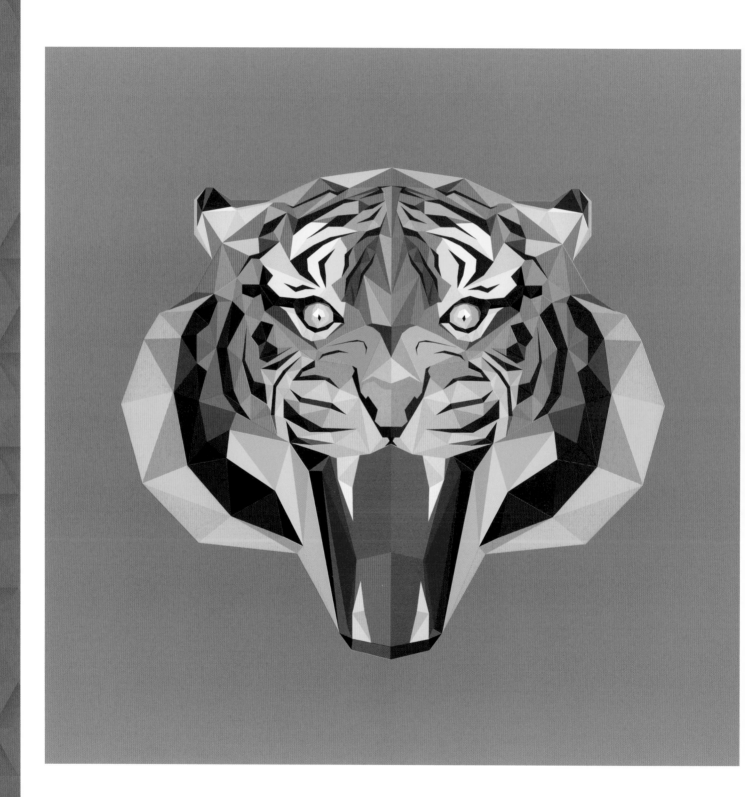

LION HEAD

SEE **PAGE 105** FOR PROJECT

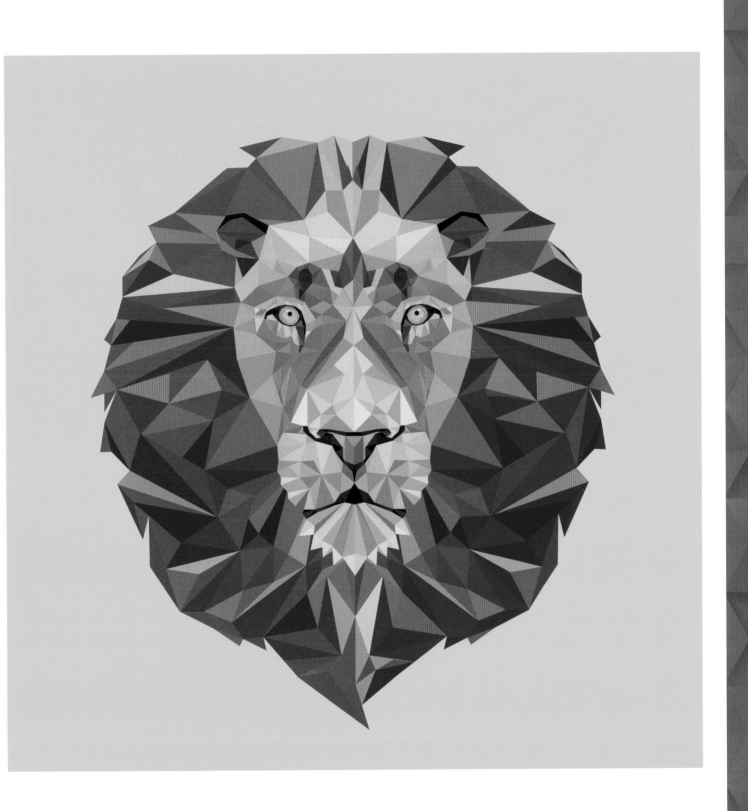

LEOPARD HEAD

SEE **PAGE 107** FOR PROJECT

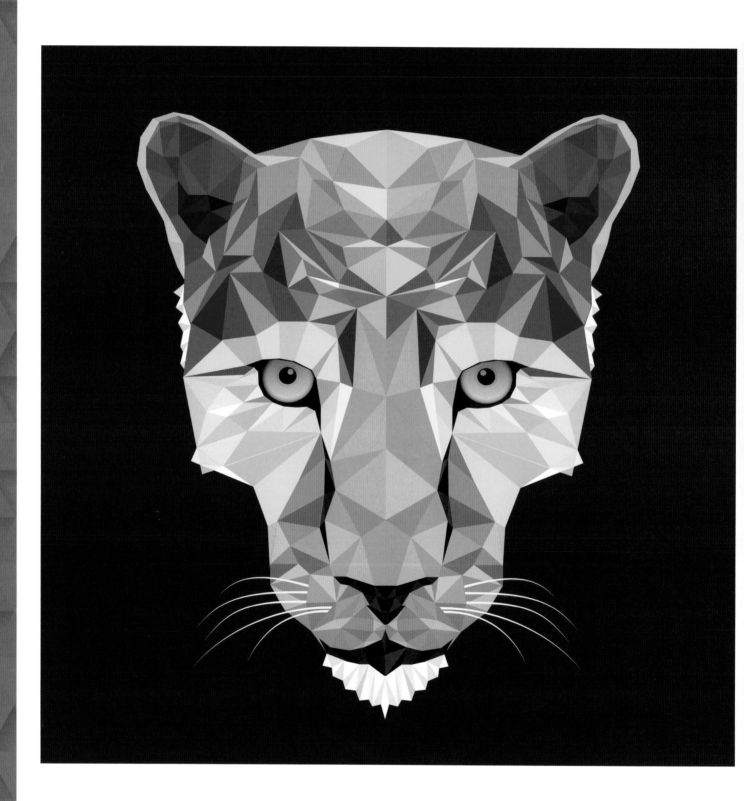

WOLF

SEE **PAGE 109** FOR PROJECT

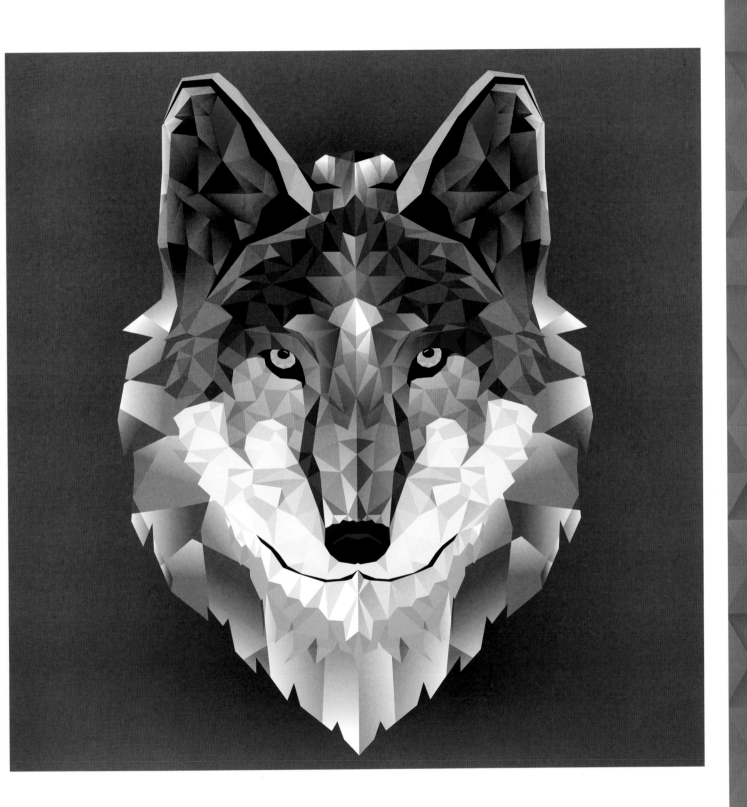

BEAR

SEE **PAGE 111** FOR PROJECT

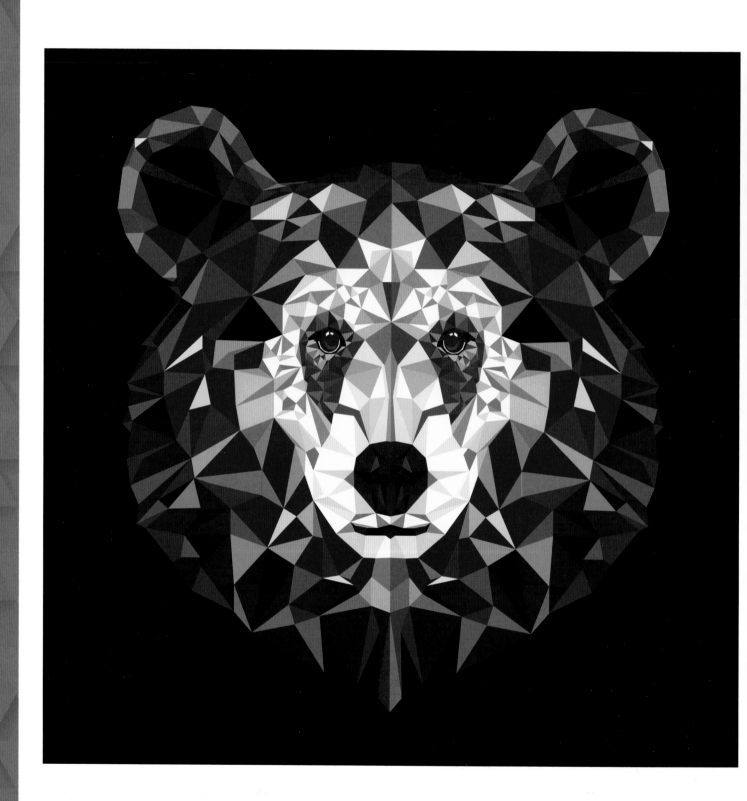

GALLERY • Advanced

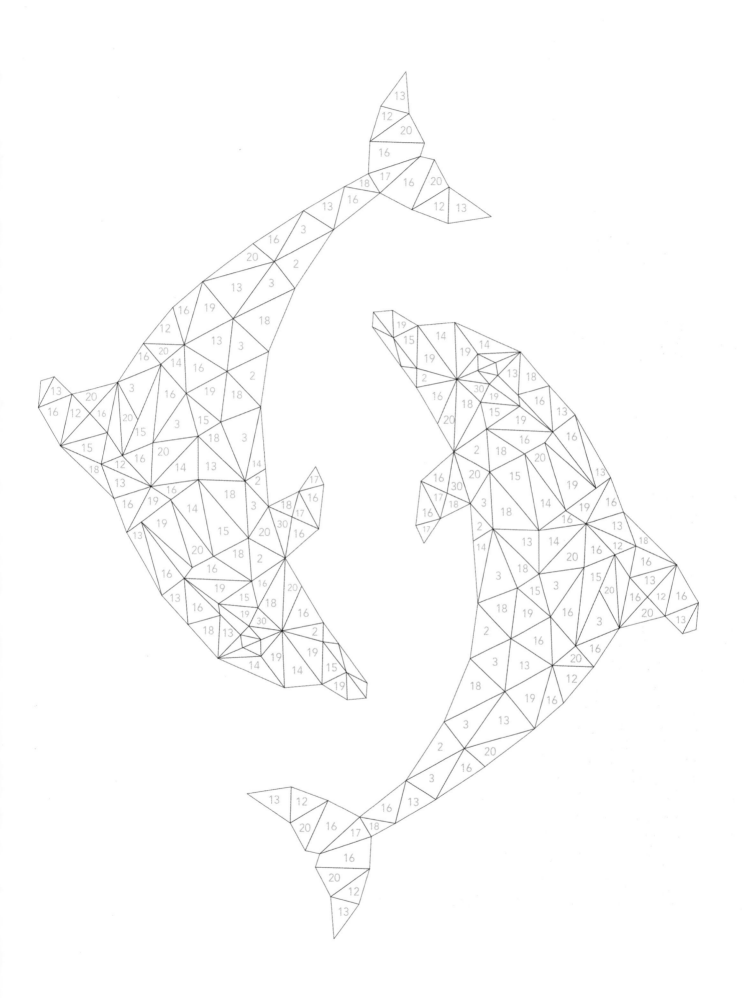

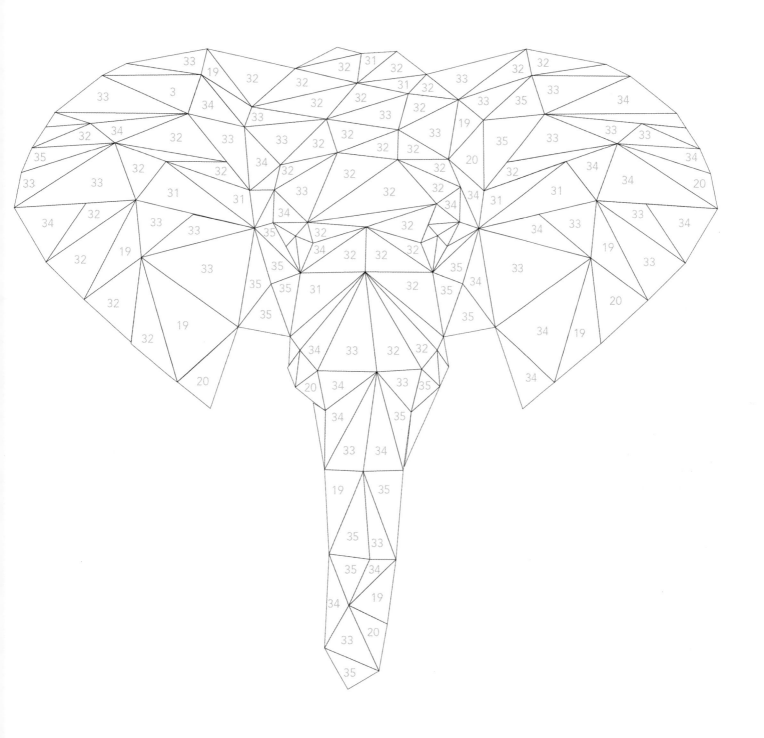

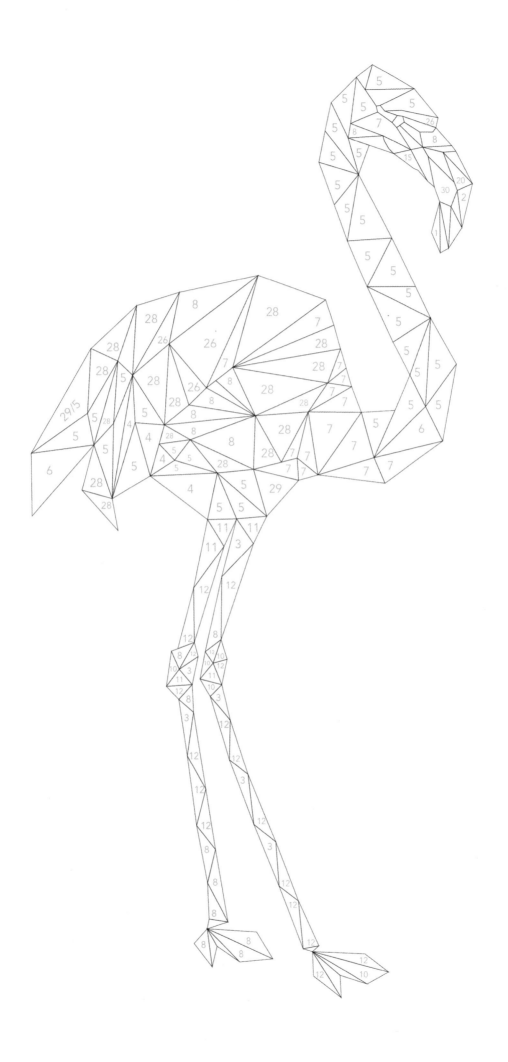

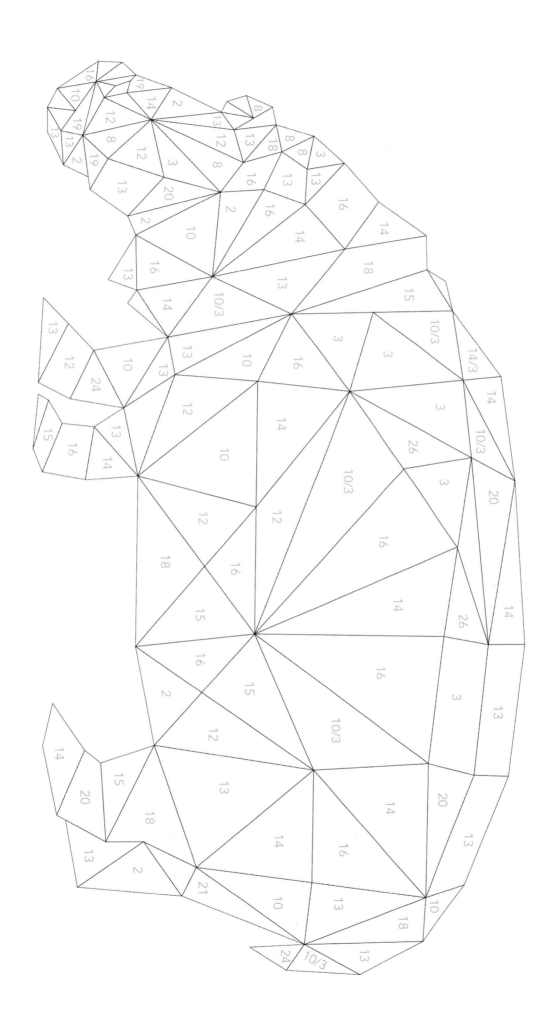

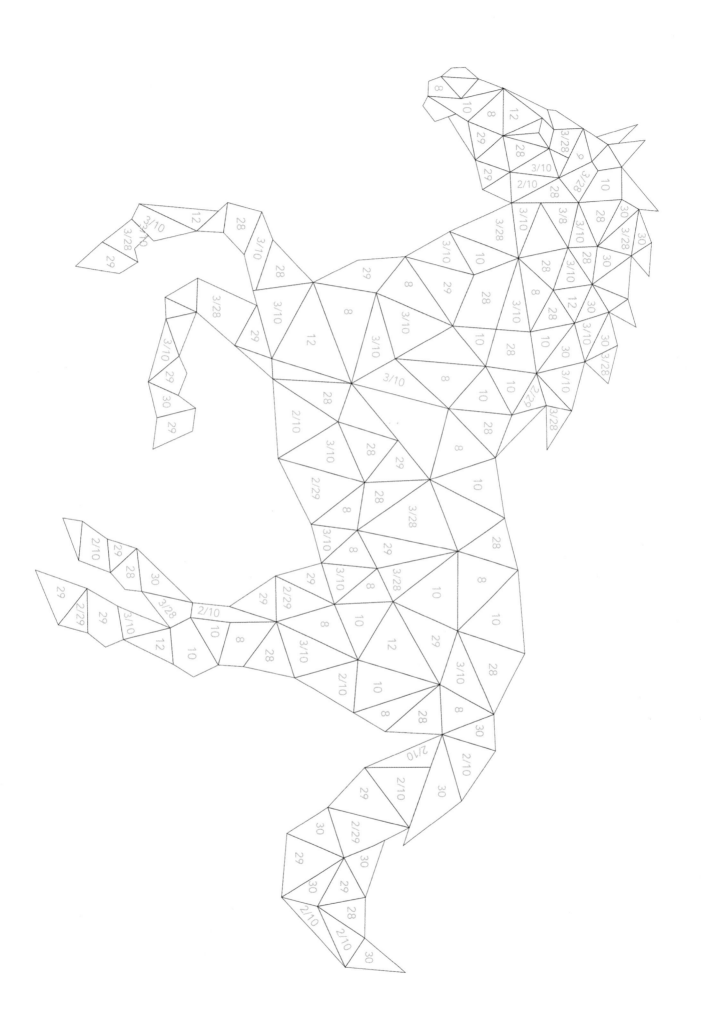

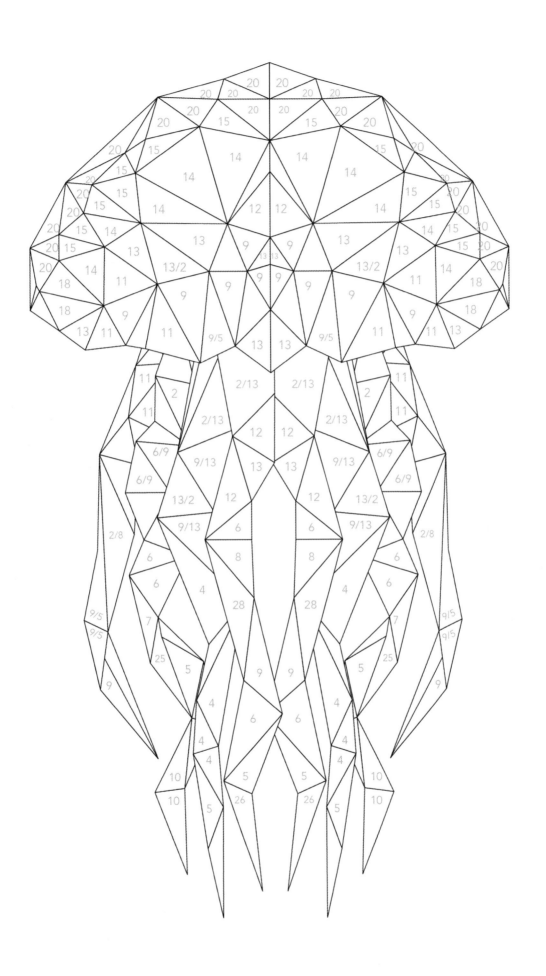

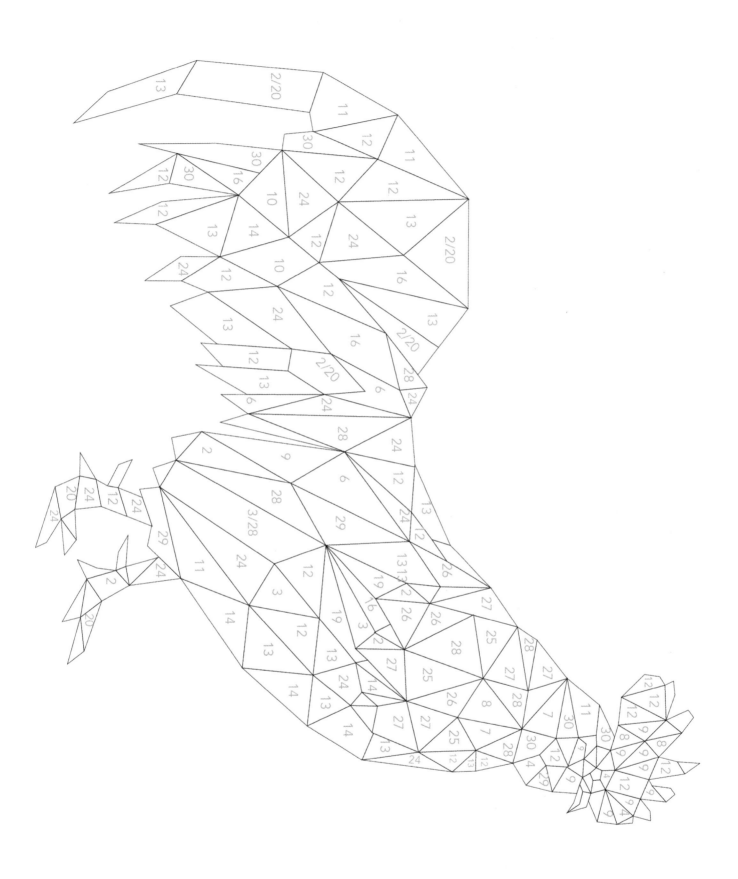

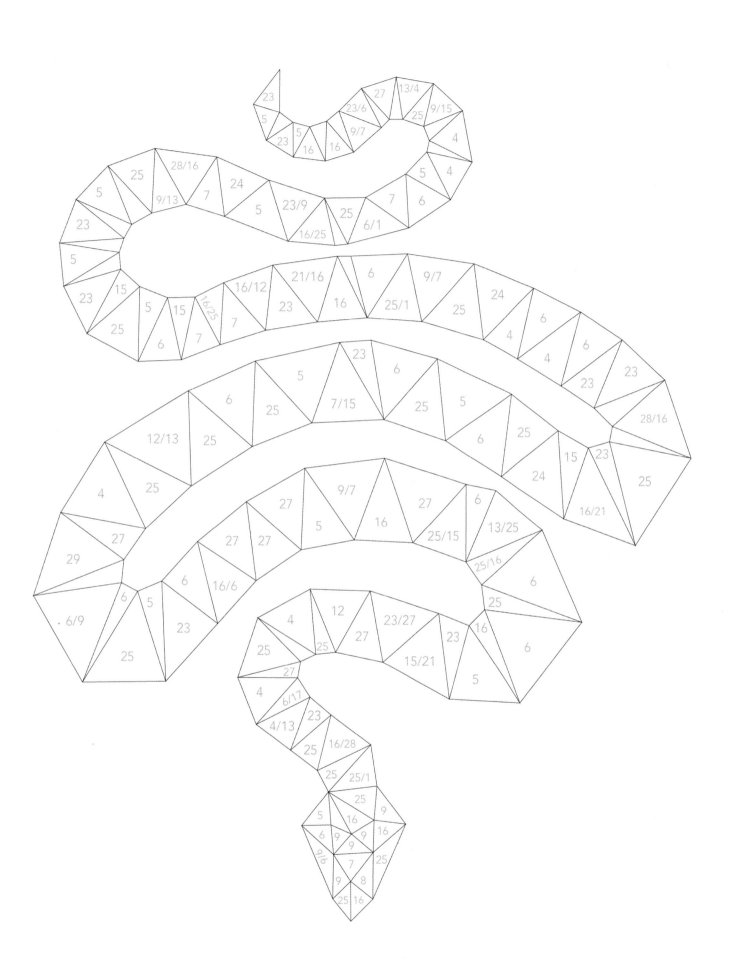

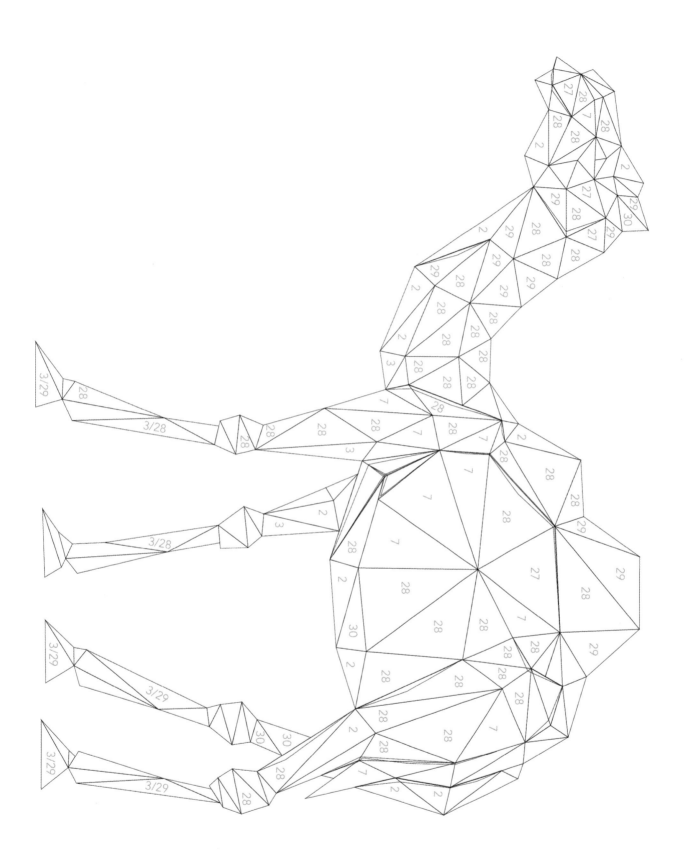

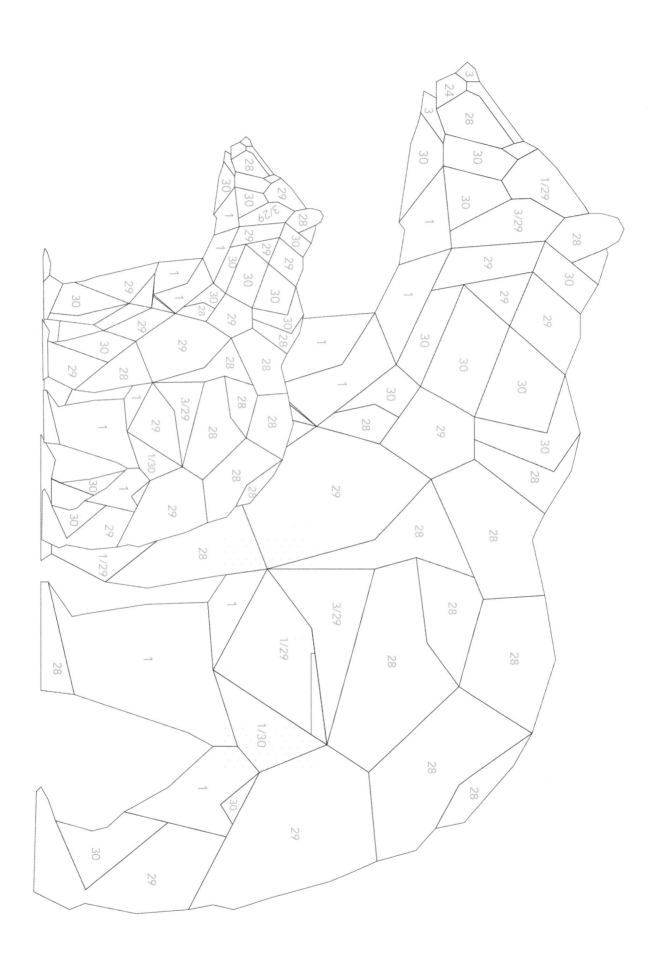

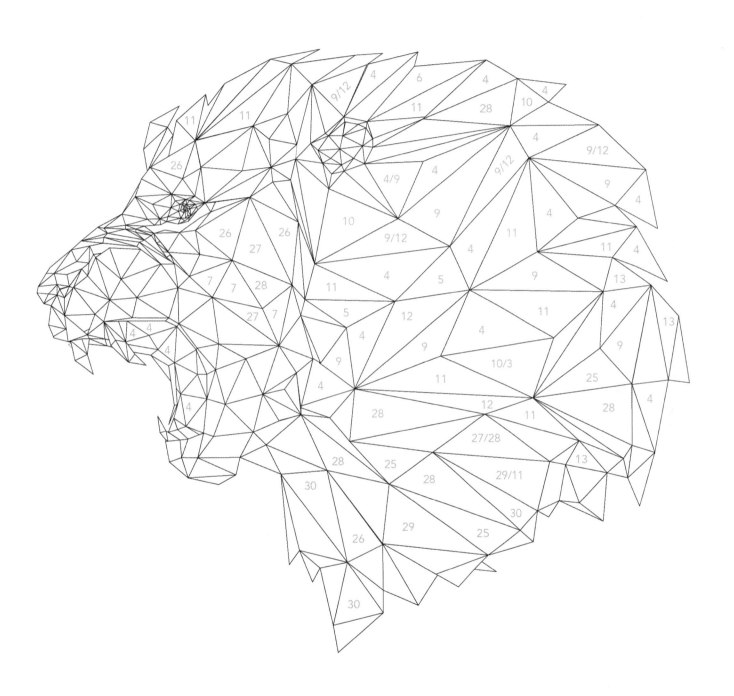

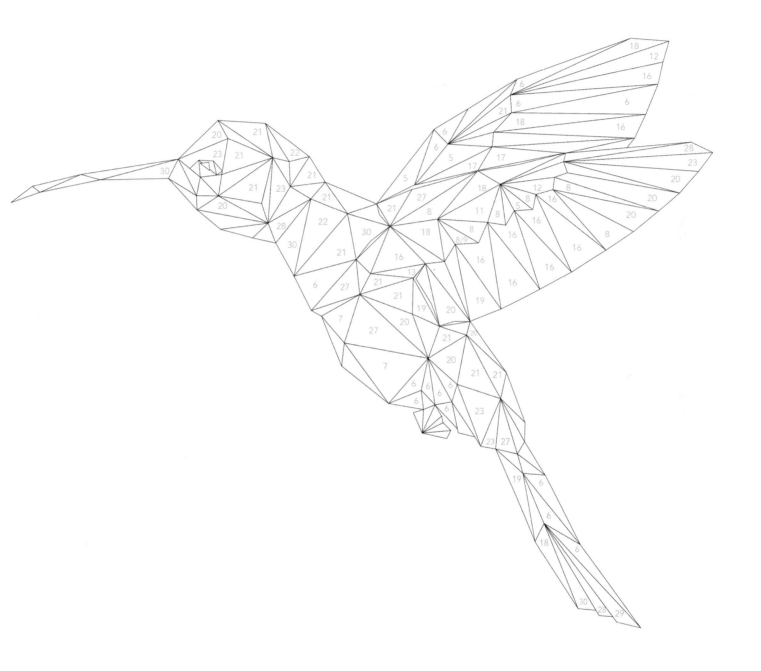

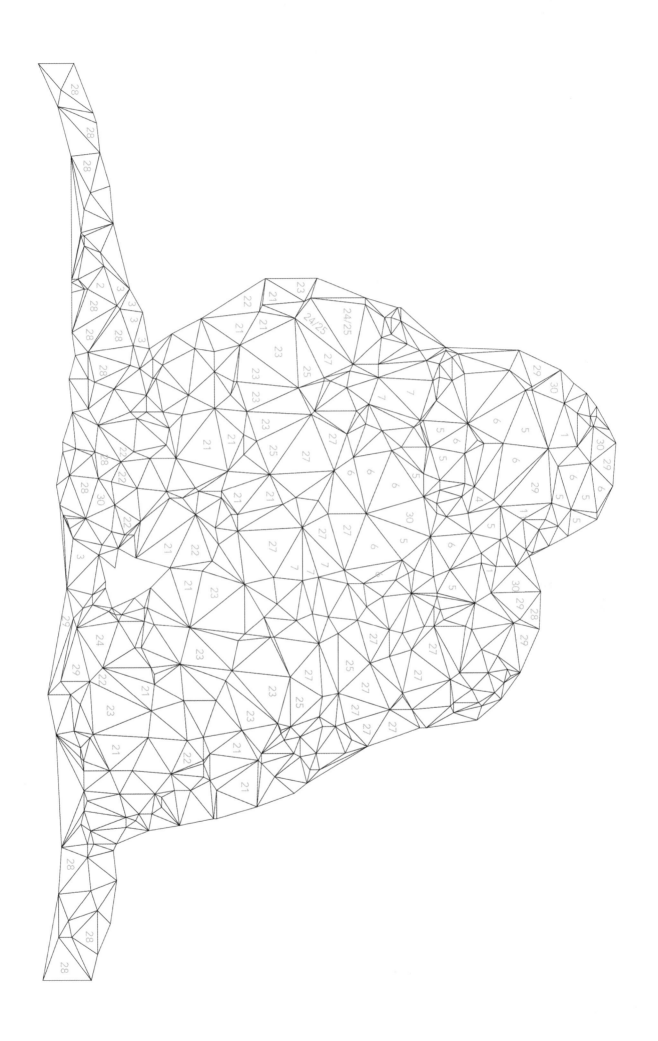

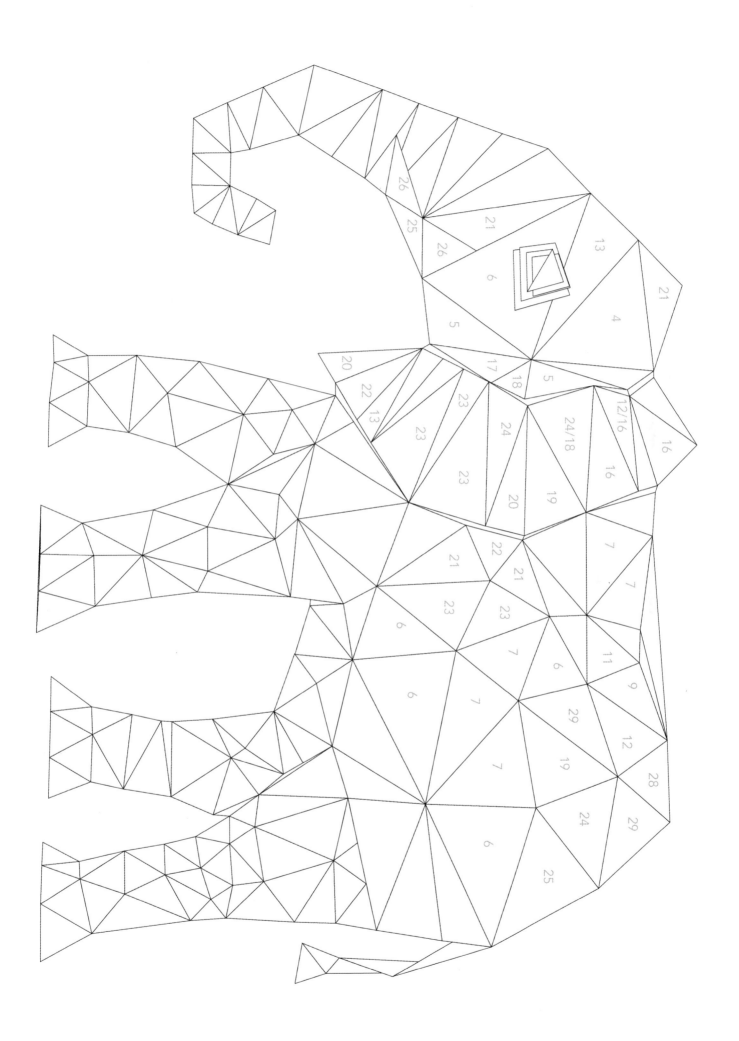

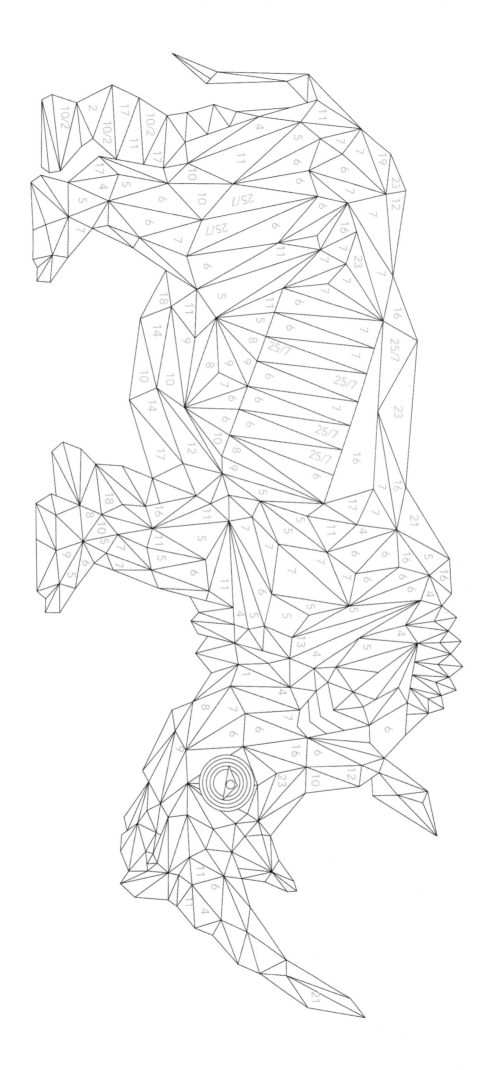

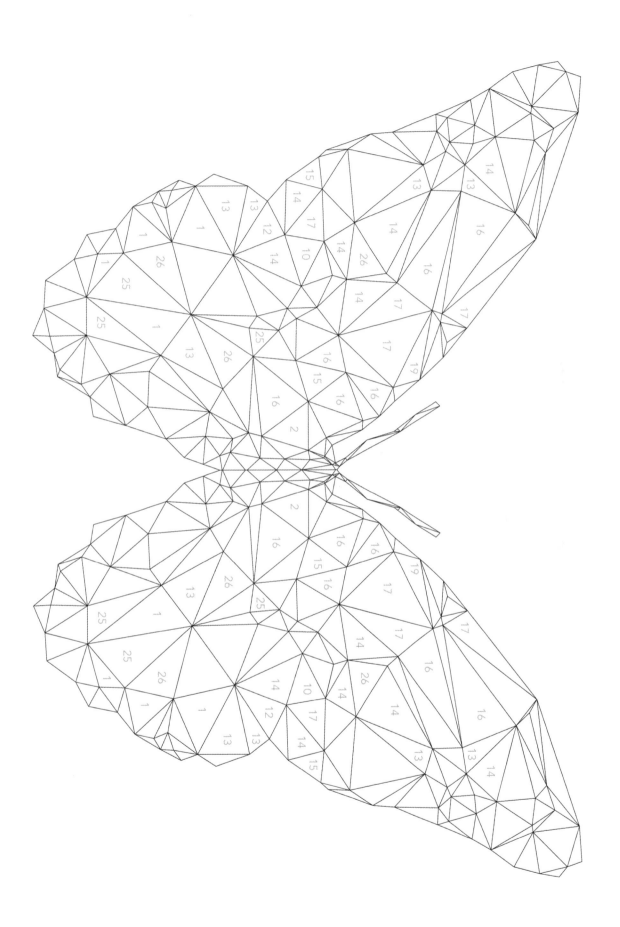

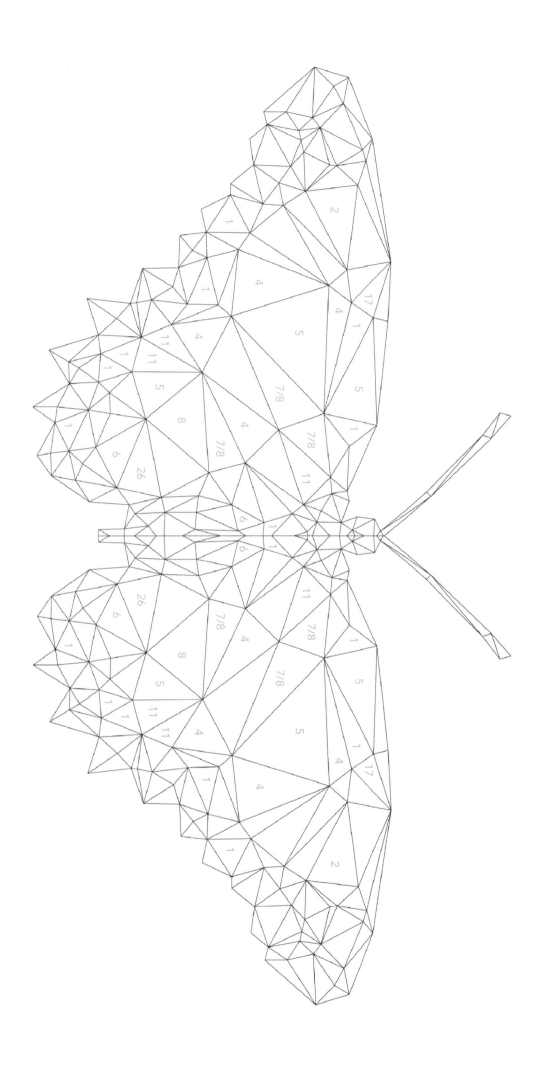

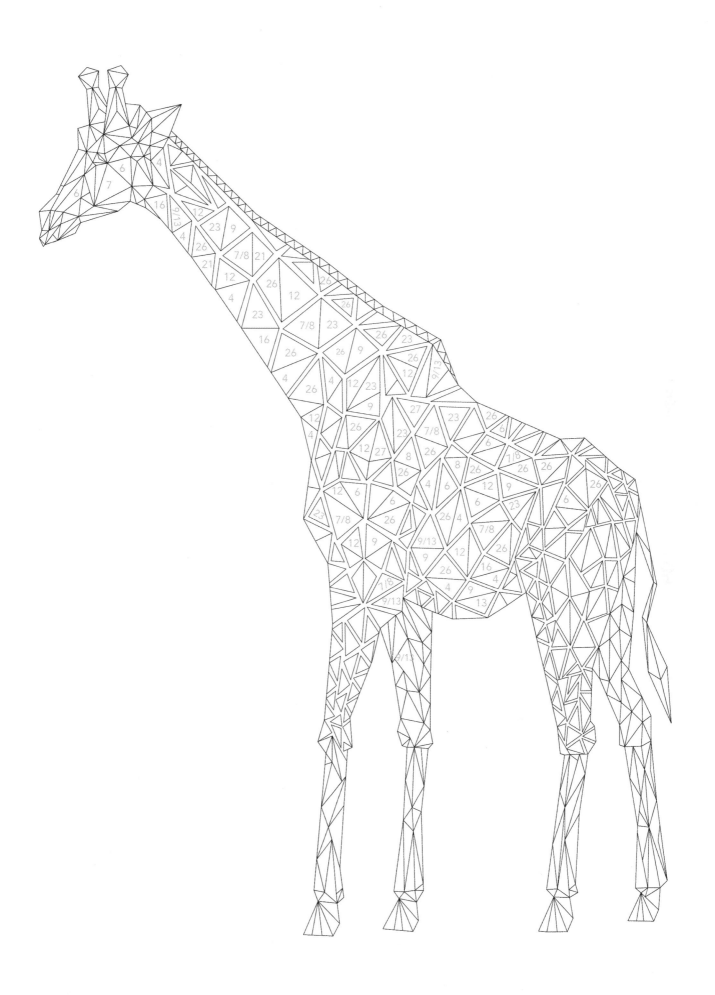

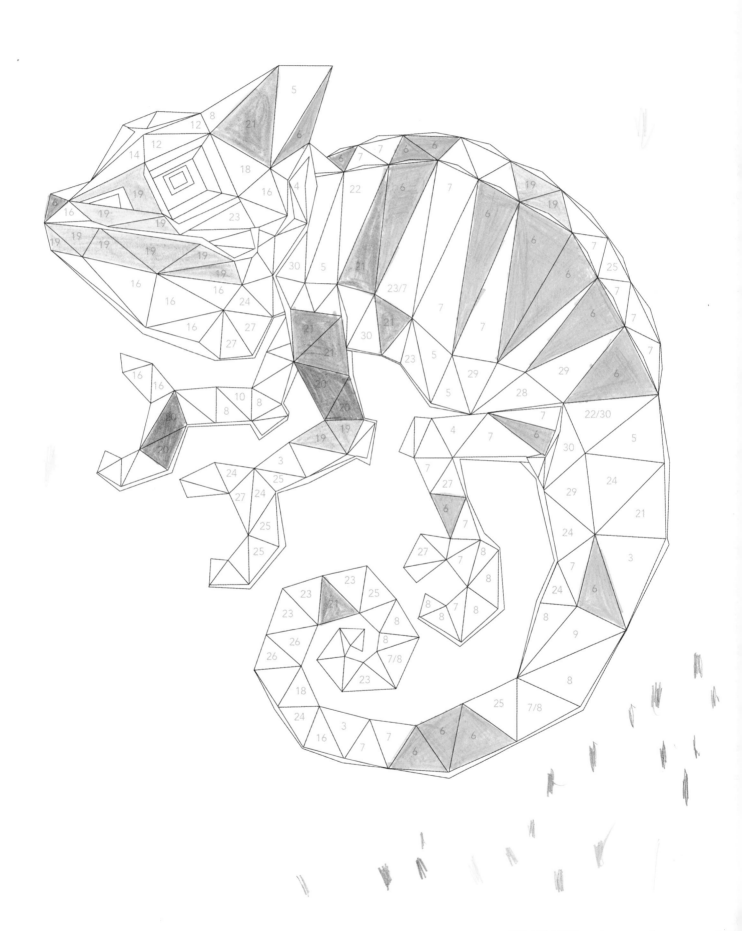

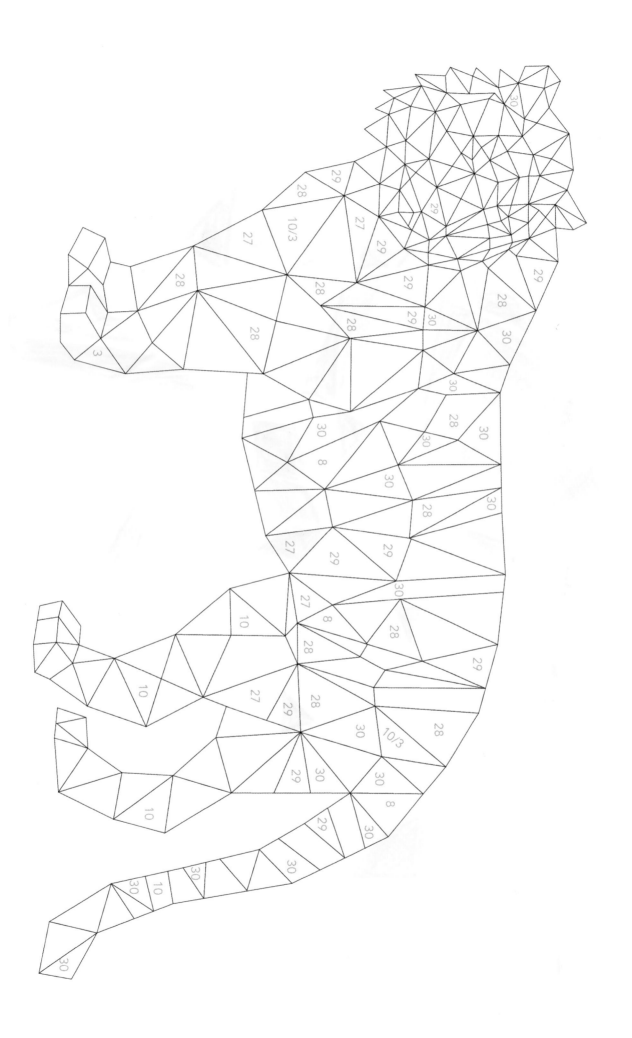

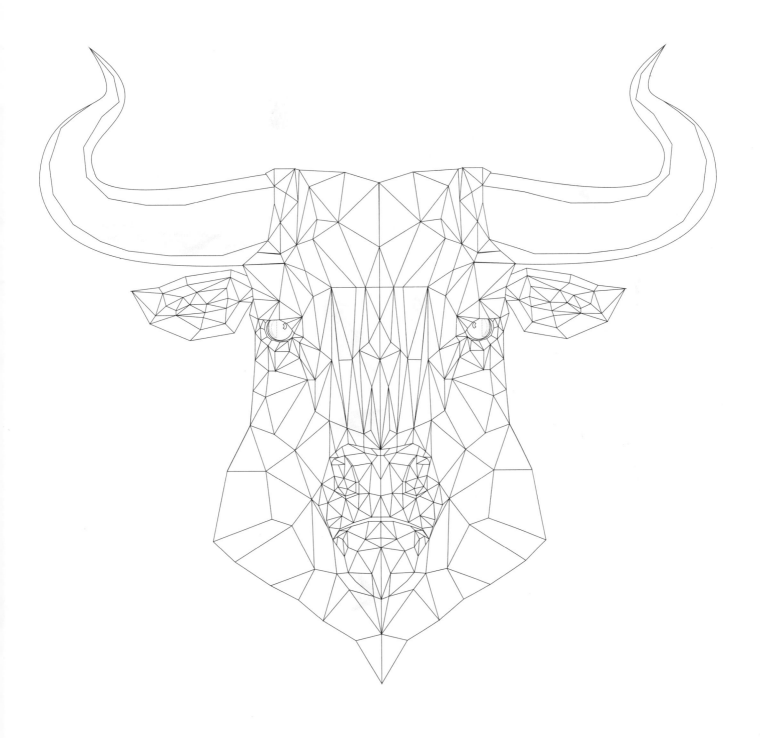

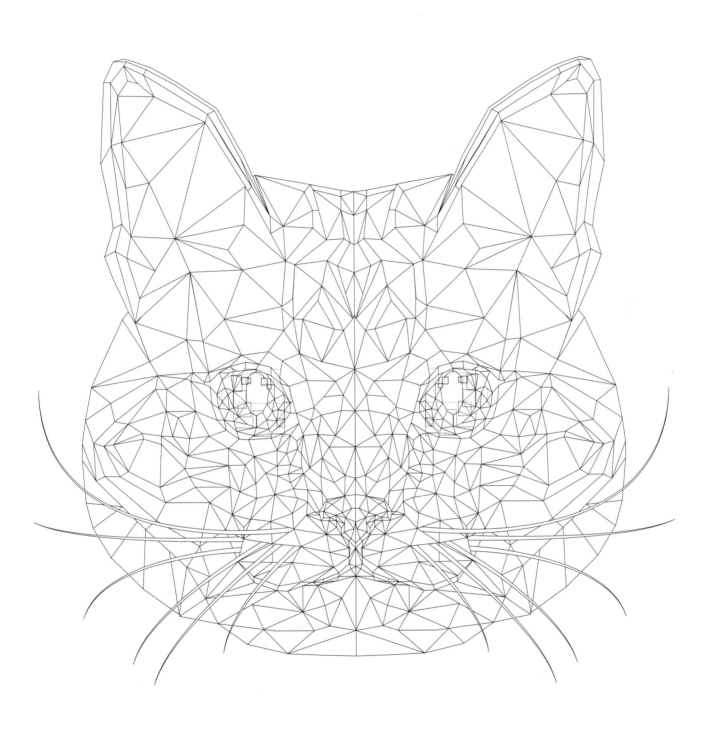

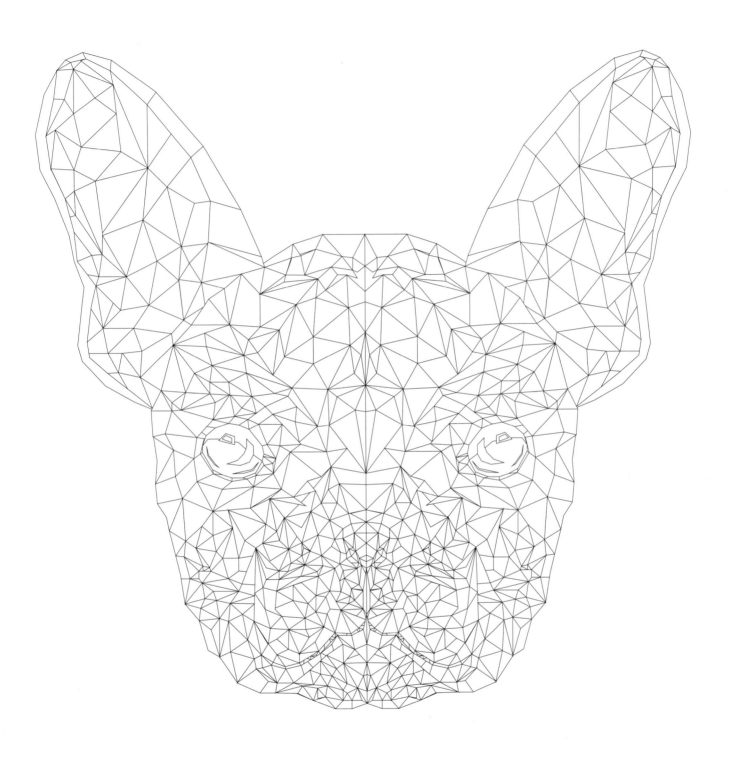

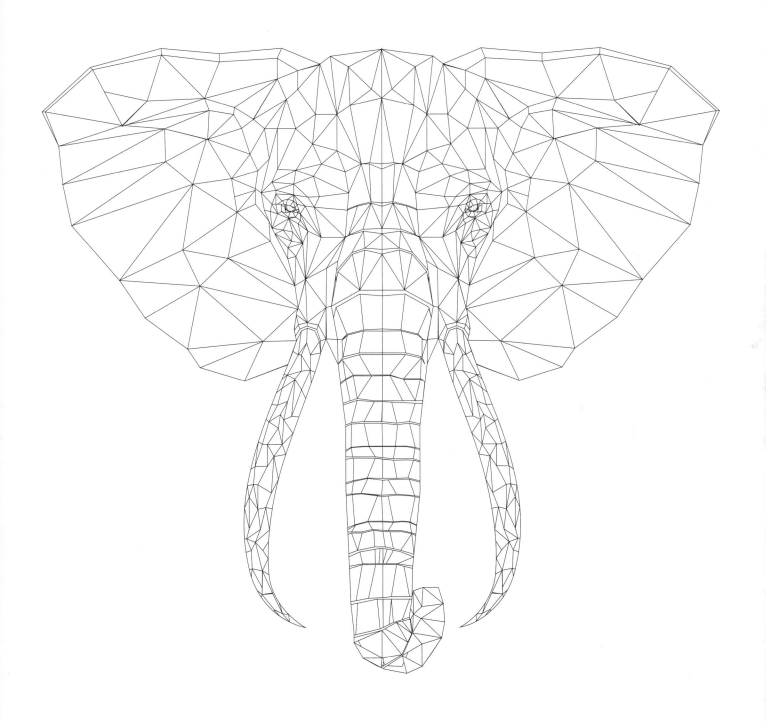

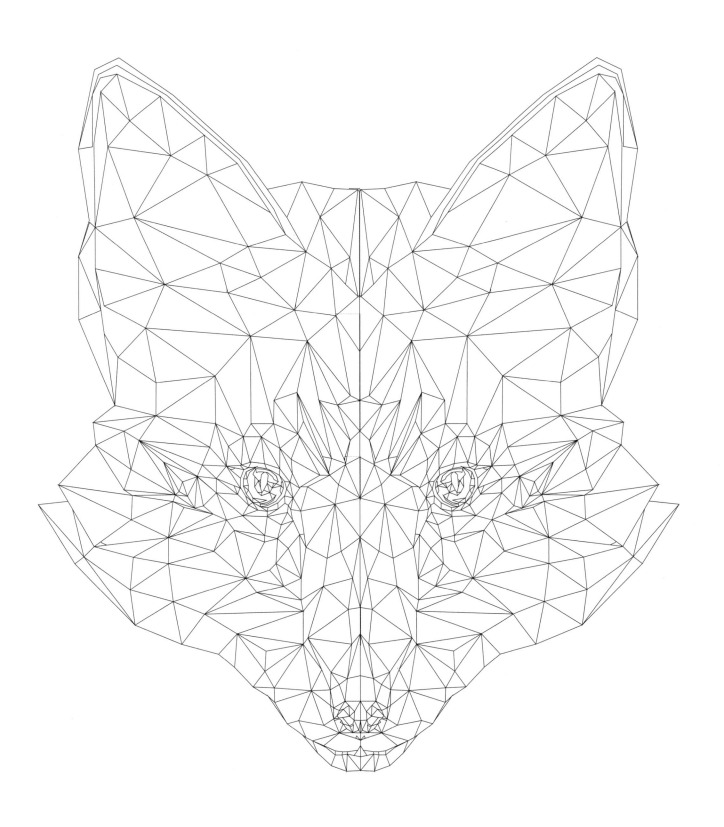

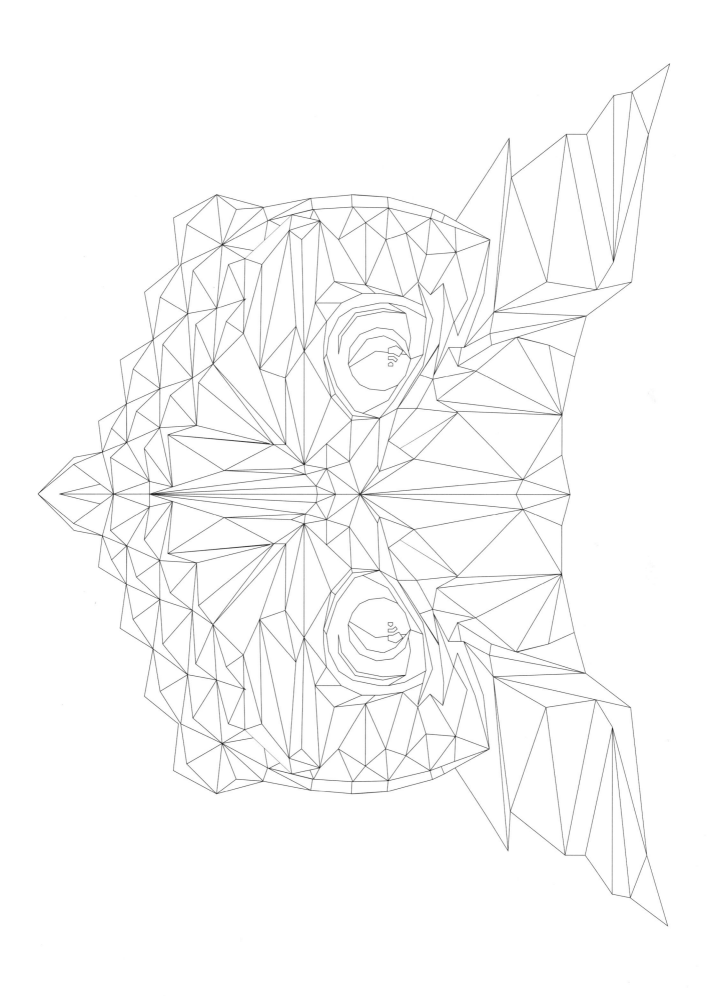

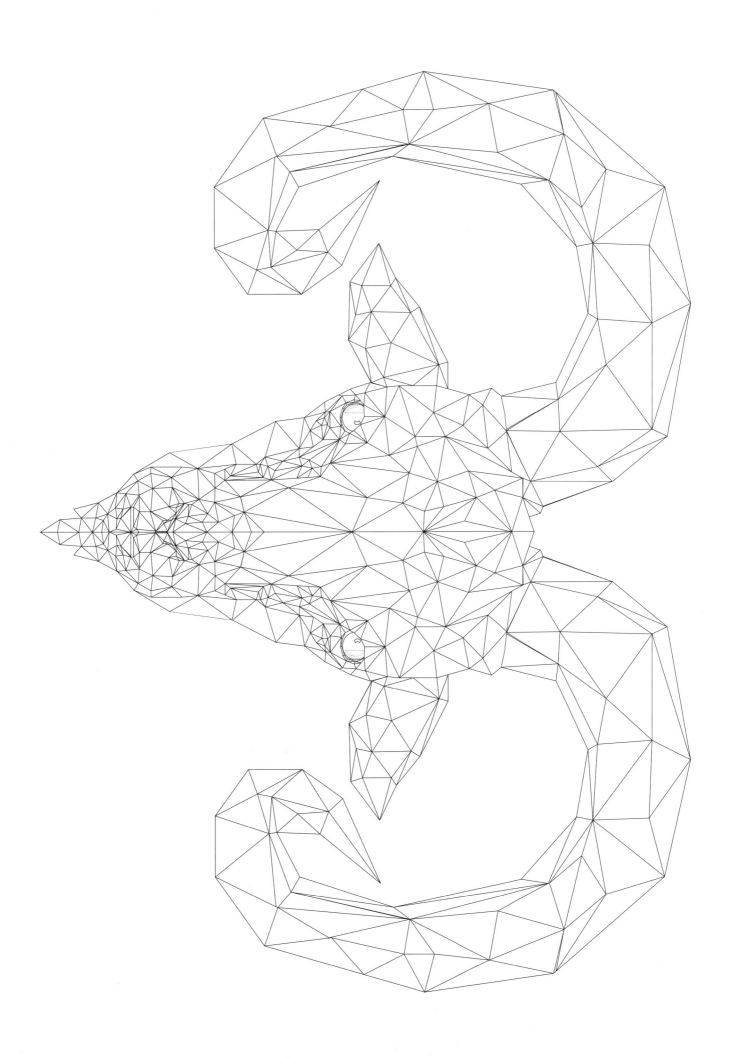

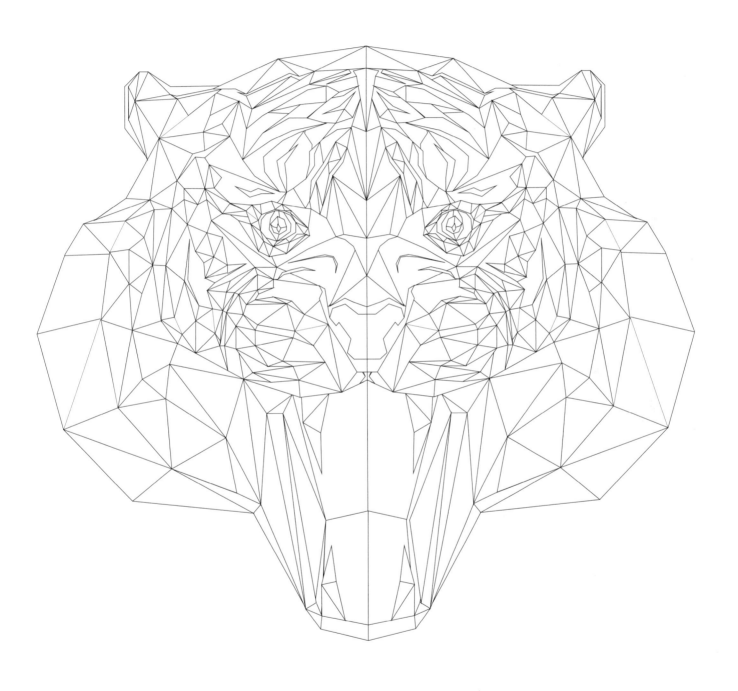

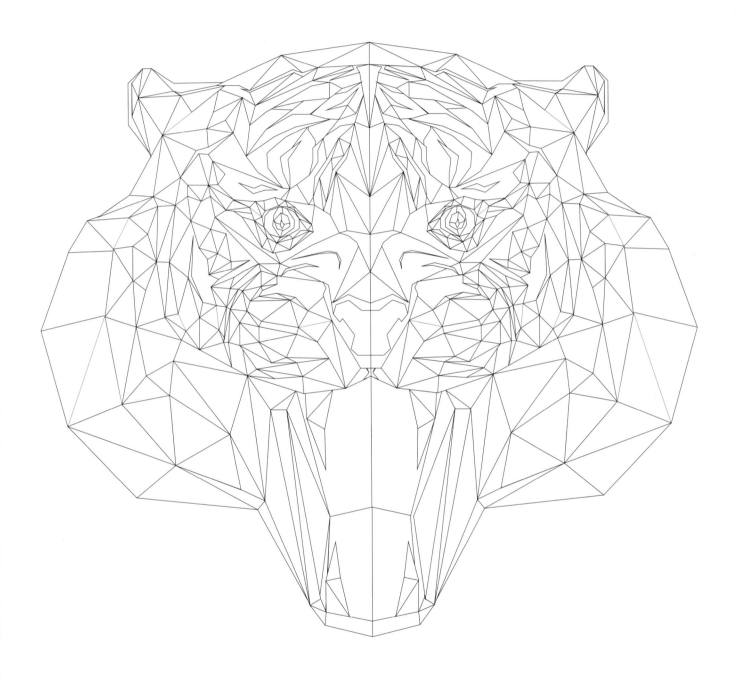

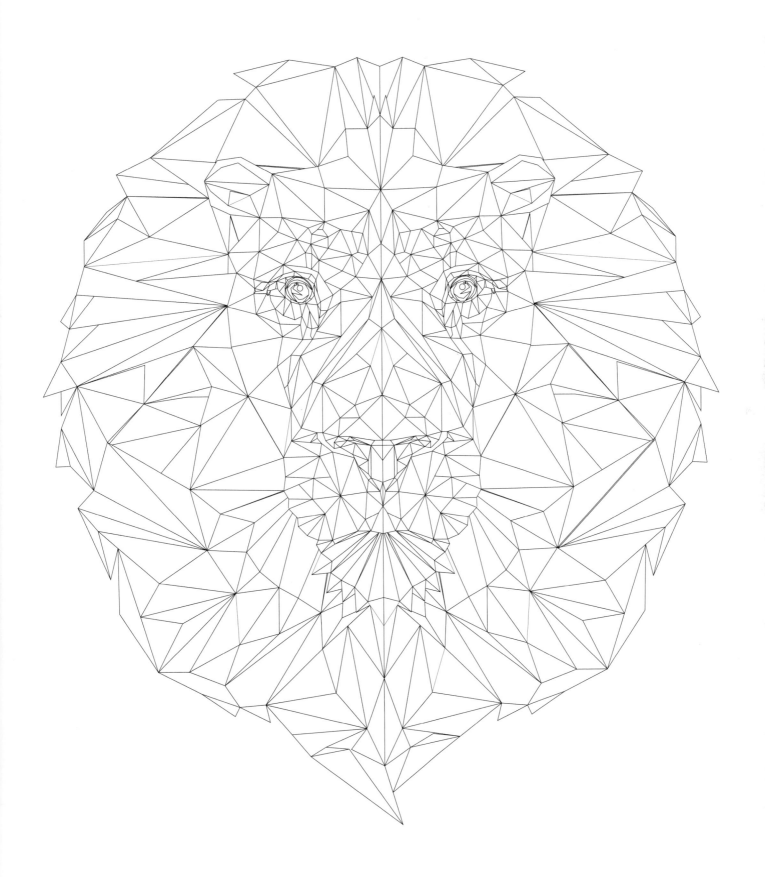

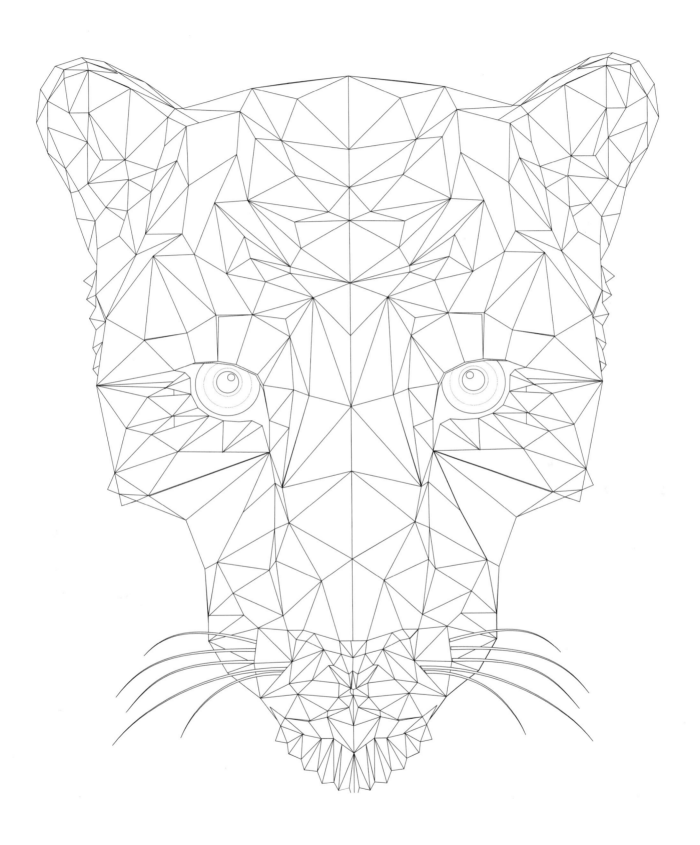

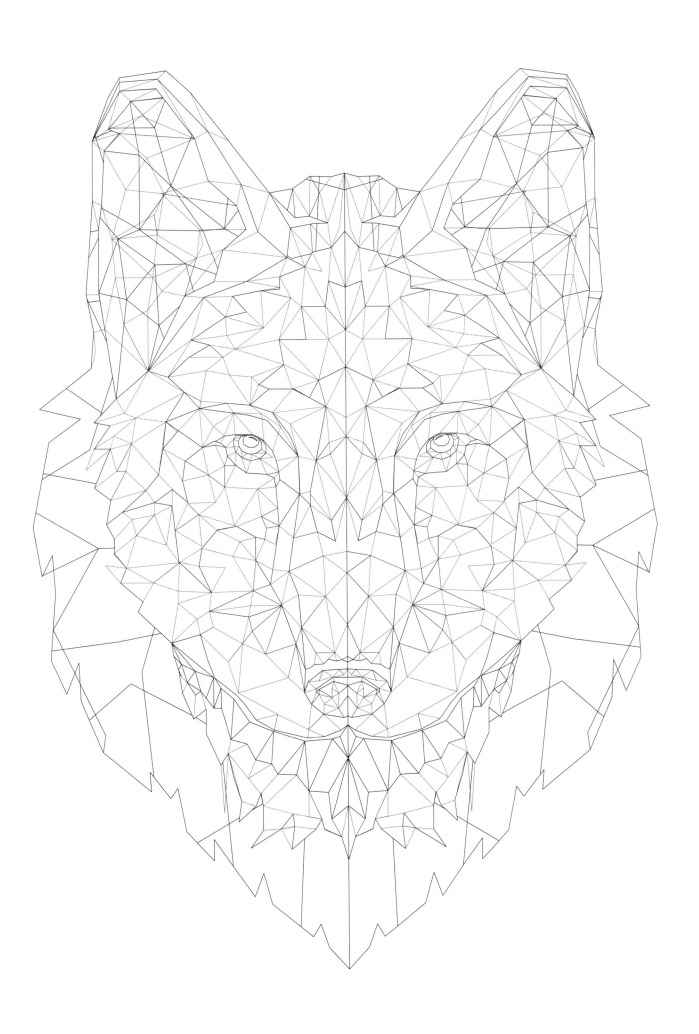

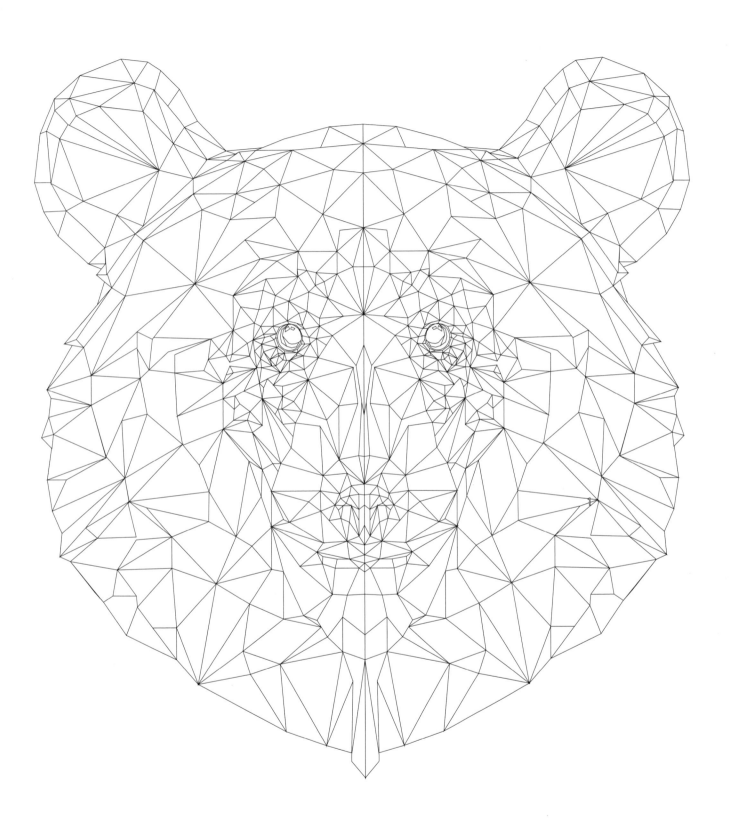